EYEWITNESS ◉ GUIDES

IMPRESSIONISM

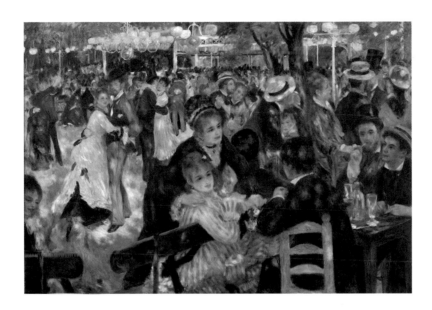

Register showing Bazille's entry into the Zouave regiment

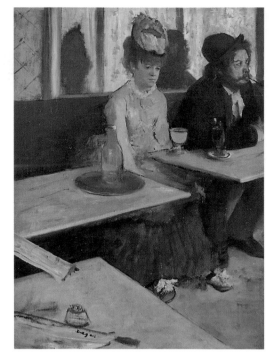

Edgar Degas, *L'Absinthe*, 1876

19th-century match holder, from a Paris café

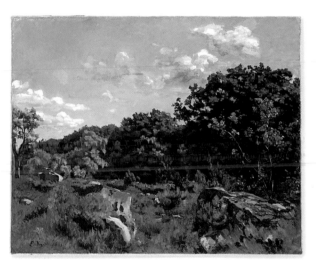

Frédéric Bazille, *Landscape at Chailly*, 1865

Edgar Degas, *The Tub*, c.1886

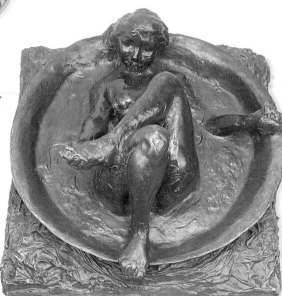

Train timetable

Postcards of Argenteuil

Claude Monet, *Train in the Countryside*, c.1870–71

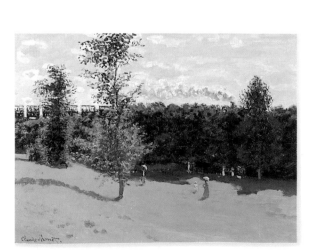

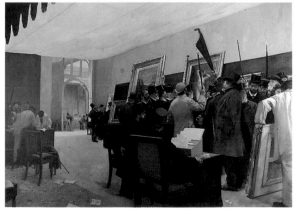

Henri Gervex, *The Salon Jury*, 1885

EYEWITNESS ◉ GUIDES

IMPRESSIONISM

JUDE WELTON

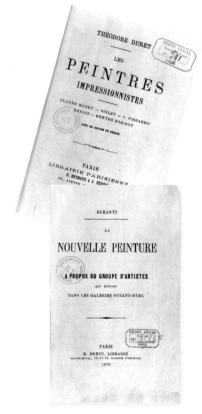

The first pamphlets dedicated
to Impressionist principles

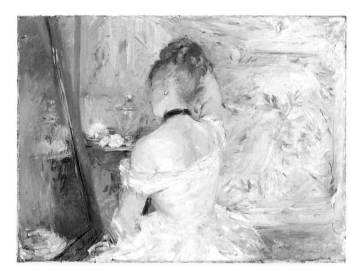

Berthe Morisot, *Lady at her Toilette*, c.1875

19th-century
snapshot camera

Photograph of
the Pont des
Arts in 1867

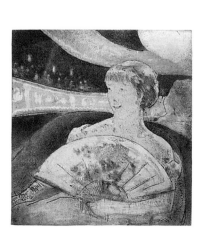

Mary Cassatt,
In the Opera Box, c.1880

A theatre fan

Pissarro's letter sketch of a
painting sent to Durand-Ruel

DORLING KINDERSLEY

LONDON • NEW YORK • SYDNEY • MOSCOW

IN ASSOCIATION WITH

THE ART INSTITUTE OF CHICAGO

Etching and drypoint
tools, with a copper plate

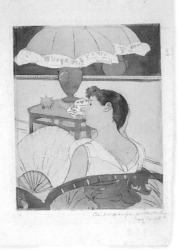

Mary Cassatt,
The Lamp, 1891

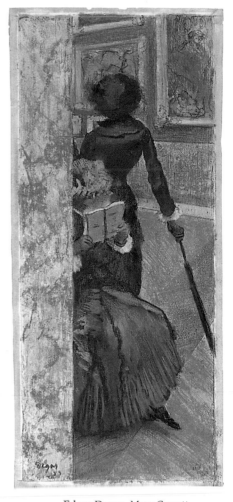

Edgar Degas, *Mary Cassatt
at the Louvre*, 1885

A DORLING KINDERSLEY BOOK

www.dk.com

To mum and dad

Editor Luisa Caruso
Art editor Liz Sephton
Assistant editor Louise Candlish
Assistant designer Simon Murrell
Senior editor Gwen Edmonds
Senior art editor Toni Kay
Managing editor Sean Moore
Managing art editor Tina Vaughan
Picture researcher Julia Harris-Voss
DTP designer Doug Miller
Production controller Meryl Silbert

This Eyewitness ®/™ Art book
first published in Great Britain in 1993 by
Dorling Kindersley Limited,
9 Henrietta Street, London WC2E 8PS

2 **4** 6 8 10 9 7 5 3

Copyright © 1993 Dorling Kindersley Limited
Text copyright © 1993 Jude Welton

A CIP catalogue record for this book is
available from the British Library

ISBN 075136147 X

Colour reproduction by GRB Editrice s.r.l.
Printed in China by Toppan Printing Co., (Shenzhen) Ltd

Photograph of the American art
collector, Bertha Palmer

Fashionable
veiled hat

Constantin Guys'
sketch of the
Champs-Elysées

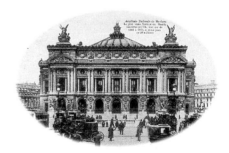

The Paris Opéra

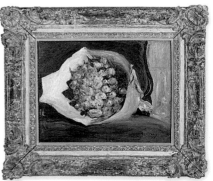

Auguste Renoir,
Bouquet in a Theatre Box, c.1871

Contents

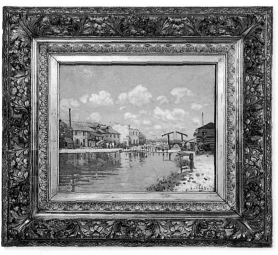

Alfred Sisley,
Saint-Martin Canal, 1872

What is Impressionism?

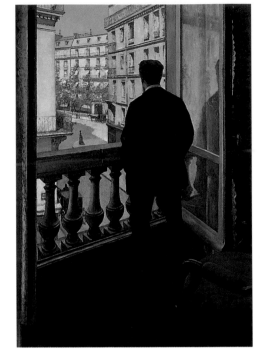

IMPRESSIONISM DEFIES EASY DEFINITION. Although it now refers to the most popular movement in Western art, it originated as a term of abuse – applied to an exhibition of works that appeared shockingly sketchy and unfinished. The artists who created these works were united in their rejection of the old, "tame" art encouraged by the official Salon (p. 18), but their artistic aims and styles varied. They did have two fundamental concerns – depicting modern life and painting in the open air. Yet neat "group definitions" fail even here. Alfred Sisley, for example, had little interest in anything but landscapes, while Edgar Degas ardently opposed painting out of doors. Despite their differences, Claude Monet, Berthe Morisot, Auguste Renoir, Camille Pissarro, Alfred Sisley, Gustave Caillebotte, Edgar Degas, and Mary Cassatt developed a new way of depicting the world around them, and, together with other artists, they displayed their work in the "Impressionist exhibitions" (p. 62) held between 1874 and 1886 in Paris.

THE MAN AT THE WINDOW
Gustave Caillebotte; 1876; 116.2 x 80.9 cm (45¾ x 32 in)
A sophisticated Parisian observes city life outside his window. In its modernity, matter-of-factness, and its theme of observation, this image shows the central characteristics of Impressionism.

The making of modern Paris

Modern Paris was the catalyst, the birthplace, and the subject matter of much of Impressionist art. In the 1850s it was still a medieval city of narrow, winding streets with little sanitation or street lighting. By the 1870s, the heyday of Impressionism, the old city had been razed to the ground and rebuilt as a modern metropolis of long boulevards, lined with cafés, restaurants, and theatres.

THE EMPEROR
Commerce prospered under Emperor Napoleon III's authoritarian "Second Empire". When he became Emperor in 1851, he set out to make Paris the showpiece of Europe.

THE ARCHITECT
The Emperor's architect, Baron Haussmann, ruthlessly rebuilt Paris, displacing over 350,000 people. Evicted workers were forced to migrate to the outskirts of the city, while the affluent middle classes moved into Haussmann's elegant new buildings.

A NEW MAP OF PARIS
This map of Paris in 1871 shows how Haussmann's plans for the city created an efficient network of wide, interconnecting boulevards. During the rebuilding, he created 50 kilometres (31 miles) of new boulevards, laid out vast areas of parks and squares, built churches, and began the Opéra and the Louvre palace. In the two decades (1851–71) in which the Emperor was in power, the population of Paris doubled.

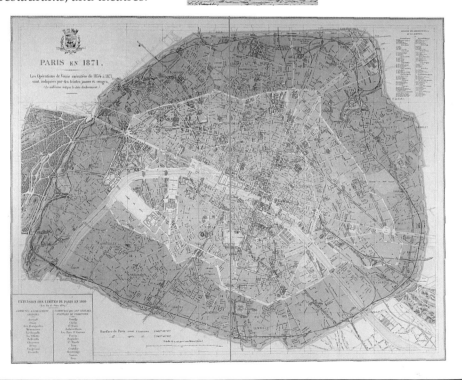

BOULEVARD HAUSSMANN
Named after its architect, this tree-lined boulevard, with its spacious pavements and elegantly balconied apartments, is typical of the Paris seen in Impressionist paintings.

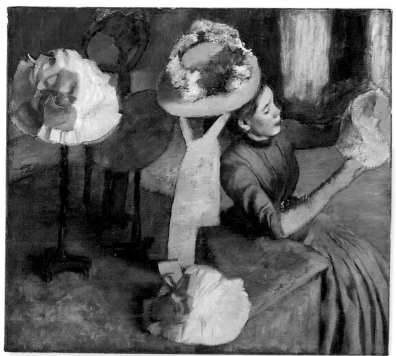

"The New Painting with regard to the ... artists who are exhibiting in the Durand-Ruel galleries"

EARLY WRITINGS
Edmond Duranty's essay of 1876, *La Nouvelle Peinture*, was the first publication about the principles of Impressionist art. Théodore Duret's pamphlet followed two years later.

THE MILLINERY SHOP
Edgar Degas; 1879–84; 100 x 110.7 cm (39½ x 43½ in)
Unlike the work of his Impressionist colleagues, Degas' art was characterized by a passion for line, and his compositions were made in the studio – "A painting is an artificial work existing outside nature", he said. Although this painting is distanced from "pure" Impressionism by its draughtsmanship and carefully worked surface, the modern Parisian theme, the off-centre composition, and the apparently unposed milliner place it firmly at the core of Impressionist art.

PARISIANS AT PLAY
The leisure activities of their fellow Parisians were a central Impressionist theme. In 1869, Renoir and Monet painted side-by-side at the popular boating and bathing resort of La Grenouillère.

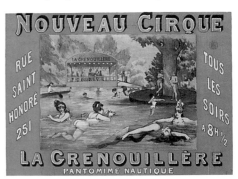

BATHERS AT LA GRENOUILLÈRE
Claude Monet; 1869; 73 x 92 cm (28¾ x 36¼ in)
The artist whose work most unequivocally represents the aims of Impressionism is Claude Monet. He was dedicated to painting in the open air, to capturing what he called "the most fugitive effects" of nature, and he used pure, bright colours, based on what his eyes saw, rather than on what the conventions of painting decreed. Abandoning traditional historical or religious themes, he also rejected the highly finished techniques of academic art. This is one of the earliest examples of the new style, in which Monet creates a vivid impression of the bustling activity at La Grenouillère, and the glittering effect of sunlight on water.

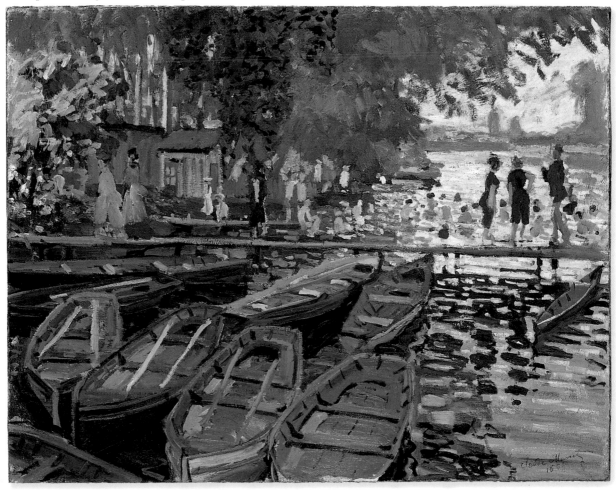

Manet's painting of modern life

"MAKE US SEE AND UNDERSTAND, with brush or with pencil, how great and poetic we are in our cravats and our leather boots," wrote the poet, Charles Baudelaire. Edouard Manet took up his friend's challenge in this remarkably innovative painting of fashionable Parisians gathered for a concert. It was hugely influential for the younger generation of artists who later became known as the Impressionists, anticipating their work in both subject and style. The modernity of the theme is matched by daringly sketchy brushwork that lacks the smooth "finish" expected in oil painting at that time, and by the unfocused, frieze-like composition. Inspired by photography and the style of Japanese prints (pp. 28–29; 54–55), Manet cropped off figures at the edge of the canvas, so that the composition gives the impression of being a slice of life that continues beyond the frame. His revolutionary attitude to art made Manet the acknowledged figure-head of the Impressionists, but he always refused to exhibit with them, craving official recognition that only the Salon could offer.

EDOUARD MANET (1832–1883)
Son of the chief-of-staff at the Ministry of Justice, Manet was the reluctant leader of *avant-garde* art, who drew inspiration from the art of the past. He met Edgar Degas – who etched the portrait above – in the Louvre.

CHARLES BAUDELAIRE
Edouard Manet; 1869; etching
During the winter of 1859–60, the poet Charles Baudelaire wrote a long essay, *Le Peintre de la vie moderne* – "The Painter of Modern Life". It not only inspired his friend, Manet, but encouraged the Impressionist artists to portray contemporary life.

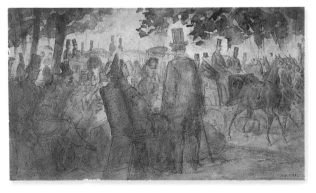

THE CHAMPS-ELYSEES
Constantin Guys; 1855; 24 x 41 cm (9½ x 16¼ in); pen and ink on paper
Manet was an admirer of Constantin Guys, the artist-illustrator whose acutely observed images of Parisian society inspired Baudelaire's influential essay. Manet owned several of Guys' pen-and-ink washes: the jaunty, staccato rhythm created by the angled top hats and the simplifications of figures in rapid sketches such as this are echoed in Manet's painting (right).

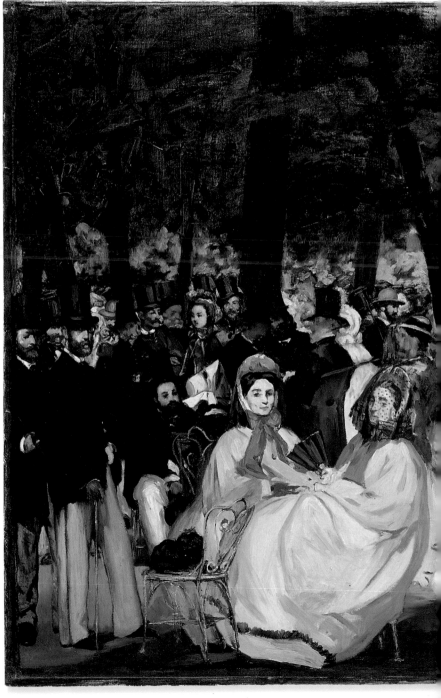

Music in the Tuileries Gardens

EDOUARD MANET *1862; 76 x 118 cm (30 x 46½ in)*

Manet presents himself (on the far left), and his sophisticated set: Baudelaire; the composer Jacques Offenbach; the painter Henri Fantin-Latour; and other members of Parisian high society are clearly identifiable. Abandoning the traditional pictorial device of leading the eye into the picture to a point of focus, Manet stretches his figures across the canvas in a flat band. Some critics saw this as a simple inability to compose a picture. But although Manet contrived to make the composition appear unplanned, it was carefully constructed in the studio from open-air studies made in the Tuileries.

Top hat: fashion symbol of the *flâneur*

FASHIONABLE HATS
Manet himself epitomized Baudelaire's concept of the modern artist as a *flâneur*, a dandy who observes life with cool detachment. The dandy's trademark was the top hat, which appears throughout the painting below. Baudelaire maintained that fashion was an aspect of modernity that should be portrayed in art.

Veiled hat, similar to that worn by Mme. Lejosne (below)

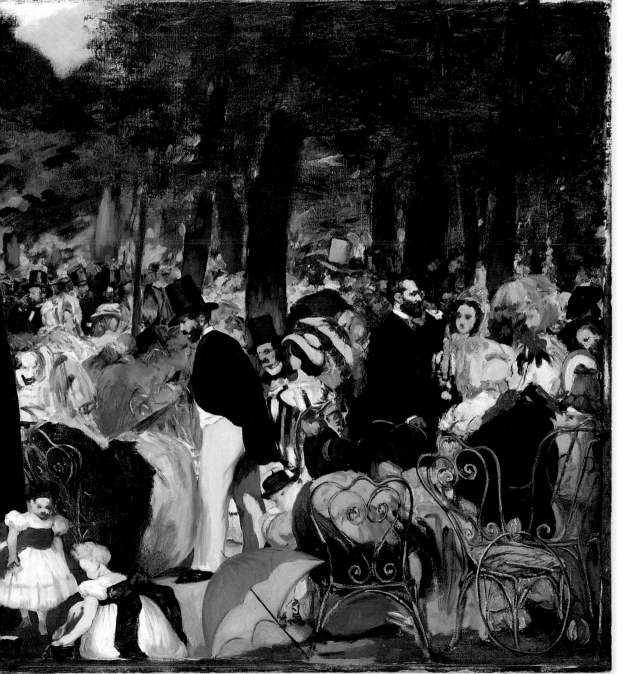

GREEN CANOPY
Broken only by a triangle of blue sky, a green canopy of leaves forms a dark band across the top of the canvas, emphasizing the pattern of light and dark created by the figures below.

UNFINISHED FIGURES
The painting of the figures shows Manet's bold new technique. Rather than carefully modelling his forms, he has used contrasting blocks of light and dark colour. Some faces are detailed, but others are barely sketched in.

SPLASHES OF COLOUR
Among the dominant black coats and top hats of the assembled dandies, the pale dresses and blue, red, and orange ribbons stand out as vivid patches of brightness.

The new metal chairs in the Tuileries form part of the painting's design

Student days

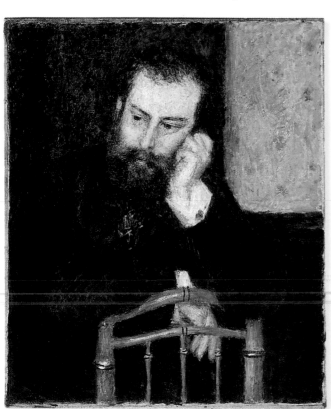

LOST ILLUSIONS
Charles Gleyre; 1843; 156 x 238 cm (61¼ x 93¾ in)
Gleyre's immaculately executed, mythical scene won a medal at the Salon in 1843. In the same year, he opened his teaching studio, where he taught for 21 years.

M OST OF THE FUTURE IMPRESSIONISTS met as students in the teaching studios of Paris in the late 1850s and early 1860s. They had arrived via a variety of routes. The oldest of the group, Camille Pissarro, had trained in the West Indies before he met Claude Monet and Paul Cézanne at the Académie Suisse in Paris. Unlike other studios, which provided tuition, this was run by an ex-model as a convenient place to paint and draw. Monet later bowed to family pressure and joined the studio of the respected teacher Charles Gleyre, whose art was rooted in the academic tradition. Here, he established close friendships with three fellow students: Auguste Renoir, who had painted porcelain before training as an artist; the Parisian-born Englishman, Alfred Sisley, who had rejected his family business for painting; and Frédéric Bazille, a well-to-do medical student with a passion for art.

CLAUDE MONET
Charles Emile-Auguste Carolus-Duran; 1867; 46 x 38 cm (18 x 15 in)
This portrait of Monet was made three years after Gleyre's studio had closed. Monet later created a negative impression of his teacher, noting in 1900 that Gleyre had criticized the unidealized ugliness of a nude he had drawn. Yet Gleyre supported originality in his pupils, and encouraged them to work out of doors.

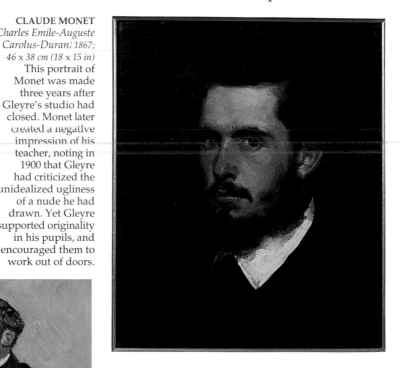

ALFRED SISLEY
Auguste Renoir; c.1875–76; 66.4 x 54.2 cm (26¼ x 21½ in)
Sisley described Gleyre's low-key approach: "the boss ... comes in twice a week and inspects the work of each student, correcting his drawing or painting." Sisley's first close friend at the studio was Renoir, who painted this portrait.

AUGUSTE RENOIR
Frédéric Bazille; 1867; 62 x 51 cm (24½ x 20 in)
Renoir recalled that Gleyre left his pupils "to their own devices", but one incident marks Renoir's own response to academic art. Glancing at his attempts to copy a model, the master remarked: "No doubt it is to amuse yourself that you are dabbling in paint?" "Yes, of course," replied Renoir, "If it didn't amuse me, I certainly wouldn't do it." Bazille's portrait of his friend captures Renoir's edgy, nervous temperament.

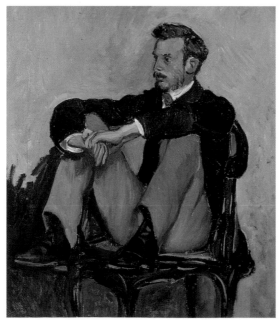

FREDERIC BAZILLE
Auguste Renoir; 1867; 105 x 73.5 cm (41¼ x 29 in)
Gleyre's students were a close group. Renoir's portrait of Bazille was painted, like Bazille's portrait of him, in 1867. The wealthy artist was supporting Renoir by allowing him to live in his flat. A penniless Monet joined them, too. When Bazille took over a studio and apartment in the Batignolles (p. 16), Renoir moved with him. Sisley also lived in the same building.

Under Manet's influence

In the early 1860s, at a time when Monet, Renoir, Sisley, and Bazille all met at Gleyre's studio, another significant event occurred in the history of Impressionism. It was then that Edgar Degas met Edouard Manet. Degas had trained at the Ecole des Beaux-Arts, France's official art school, before travelling to Italy, where he studied the masters of antiquity and the Renaissance. But, under Manet's influence, he turned away from his classical subject matter to concentrate on modern-life themes. Manet also had a decisive influence on the style of another future Impressionist, Berthe Morisot, his model and protégée.

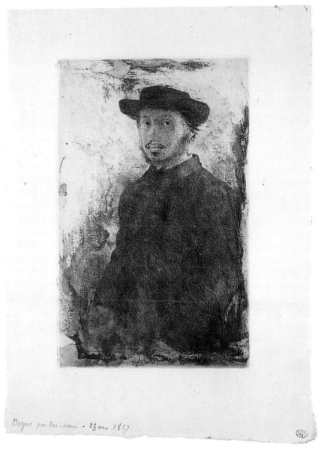

SELF-PORTRAIT
Edgar Degas; 1857;
23 x 14.3 cm (9 x 5¼ in); etching
Executed in Italy in 1857, this etching shows the characteristically sullen young Degas in artist's dress, wearing soft hat and cravat. Clearly inspired by the etched self-portraits of Rembrandt, it reveals Degas' manipulation of the 17th-century master's techniques.

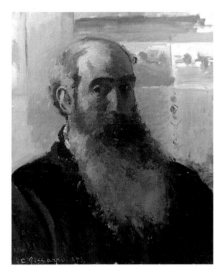

SELF-PORTRAIT
Camille Pissarro; 1873; 56 x 46.7 cm (22 x 18½ in)
Pissarro had a varied background. He studied with Beaux-Arts teachers, as well as attending informal studios. Like Morisot, he also received guidance from the great landscape artist, Camille Corot (p. 13).

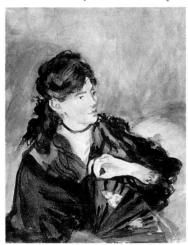

PORTRAIT OF BERTHE MORISOT
Edouard Manet; 1874; 20.9 x 16.8 cm (8 x 6½ in); watercolour
Morisot (left) was given private lessons by an academic painter, Joseph Guichard, who feared such ability in a woman could be "catastrophic ... in [her] high bourgeois milieu". She copied works by Old Masters at the Louvre, and received informal tuition from Camille Corot, but it was Manet who influenced her the most.

SKETCHING COMPETITIONS
Being female, Morisot was not permitted to enter the Ecole des Beaux-Arts. But Renoir, Degas, and Pissarro all attended classes there. At that time, training focused on drawing, and was geared towards annual competitions (left).

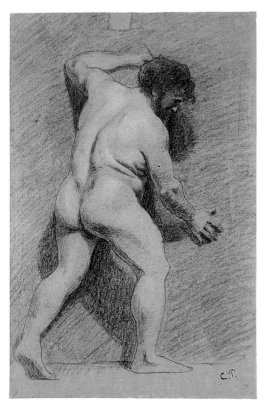

STUDY OF A MALE NUDE
Camille Pissarro; c.1855–60; 46.8 x 29.5 cm (18½ x 11½ in); charcoal and chalk on paper
Apart from Degas, Pissarro was the most prolific draughtsman of the Impressionists. This powerful charcoal study of a heavily built life model dates from shortly after his arrival in France in 1855, and was either executed at the Académie Suisse or the Ecole des Beaux-Arts.

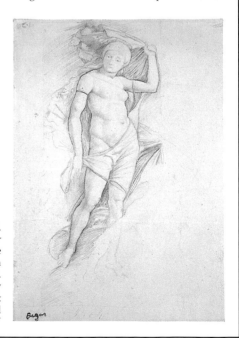

VENUS, AFTER MANTEGNA
Edgar Degas; c.1855; 29 x 20 cm (11½ x 8 in); pencil on paper
Also made in about 1855, this copy after a figure by the 15th-century painter Andrea Mantegna illustrates Degas' admiration for Renaissance art. Precisely drawn contours contain the delicately modelled figure. It was at this time that Degas met the great master J. A. D. Ingres, who advised him: "Draw lines, young man, many lines."

Painting out of doors

PAINTING IN THE OPEN AIR (*en plein air*) was central to Impressionism, with artists leaving the confines of their studios to paint directly and spontaneously from nature. However, it was not a new activity. Throughout the 19th century, it had been common practice for landscape painters to make rapid oil sketches in the open air, though these were usually considered as studies for a finished painting, to be composed later in the studio. Since the 1840s, the villages of Barbizon and Marlotte in the Forest of Fontainebleau had become associated with *plein-air* painting.

Charles François Daubigny, one of the "Barbizon School", was among the first to consider his paintings from nature as finished enough to exhibit. Significantly, he was criticized for "being satisfied with an impression". Of the group from Gleyre's studio, Monet had been converted to painting out of doors by Eugène Boudin and Johan Barthold Jongkind on the Normandy coast. And from 1863, he led painting expeditions to Fontainebleau, where he, Renoir, Bazille, and Sisley developed the language of Impressionist art.

PORTABLE EQUIPMENT
Portable easels and other equipment became available for landscape painters. Catalogues such as this, from Lefranc & Company, offered a wide range, including an outdoor painting kit (above).

OFF TO PAINT
This powerful little sketch by Cézanne shows Pissarro on his way to paint.

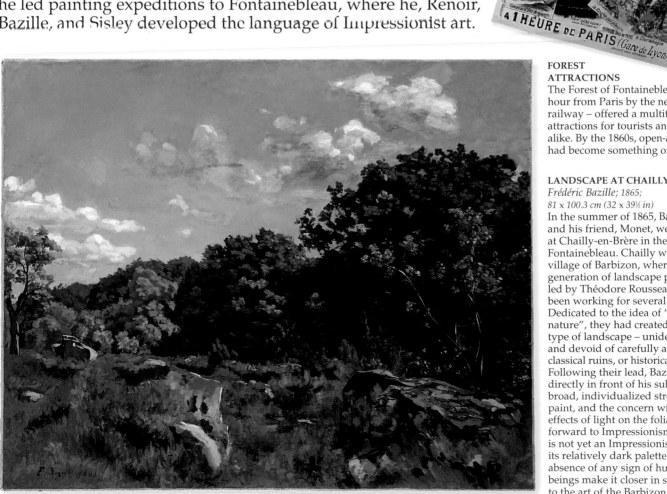

FOREST ATTRACTIONS
The Forest of Fontainebleau – just one hour from Paris by the newly built railway – offered a multitude of attractions for tourists and artists alike. By the 1860s, open-air painting had become something of a craze.

LANDSCAPE AT CHAILLY
Frédéric Bazille; 1865;
81 x 100.3 cm (32 x 39½ in)
In the summer of 1865, Bazille and his friend, Monet, were based at Chailly-en-Brère in the Forest of Fontainebleau. Chailly was near the village of Barbizon, where the older generation of landscape painters, led by Théodore Rousseau, had been working for several decades. Dedicated to the idea of "truth to nature", they had created a new type of landscape – unidealized, and devoid of carefully arranged classical ruins, or historical incidents. Following their lead, Bazille painted directly in front of his subject. The broad, individualized strokes of paint, and the concern with the effects of light on the foliage, look forward to Impressionism. But it is not yet an Impressionist landscape: its relatively dark palette and the absence of any sign of human beings make it closer in spirit to the art of the Barbizon painters.

CAMILLE COROT
(1796–1875)
Seen here beneath his painting umbrella, Corot was one of the greatest landscape artists of the 19th century, and a hero to most of the Impressionists. He taught both Morisot and Pissarro.

VIEW OF GENOA
Camille Corot; 1834;
29.5 x 41.7 cm (11½ x 16½ in)
Though Corot's *plein-air* landscapes such as this were executed as studies for studio works, even his finished paintings retain a sense of immediacy and freshness. He painted this early work on paper (he later mounted it on canvas), using broad, simplified shapes, and replacing the convention of artificially dark shadows with a high-toned luminosity. His advice to "submit to the first impression", could be seen as a central tenet of Impressionism – yet Corot disapproved of "that gang", as he called them.

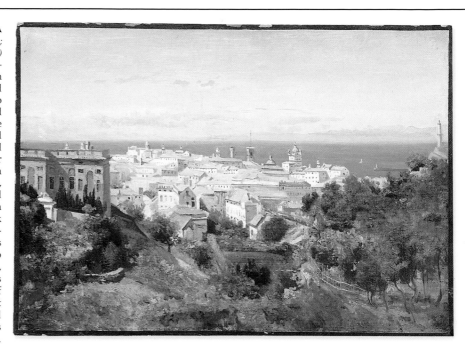

ENTRANCE OF THE PORT OF HONFLEUR
Johan Barthold Jongkind; 1864; 42.2 x 56.2 cm (16½ x 22¼ in)
Jongkind had a powerful influence on the development of Impressionism. "To him," Monet said,"I owe the final education of my eye." The atmospheric effects and thickly applied (*impasto*) brushstrokes of marine views such as this create an impressive sense of spontaneity. Yet Jongkind painted in his Paris studio, from preparatory sketches.

Collapsible tubes of paint

STORING PAINT
The invention of metal tubes in the 1840s allowed long-term storage of oil paints, making extended outdoor oil-painting trips much more feasible. Until then, oil paints were stored in little pouches made from pigs' bladders (left). The painter pierced the skin with a tack, squeezed out the paint, and used the tack as a plug. However, the paint hardened rapidly with exposure to air.

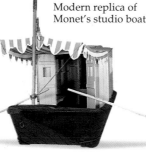

DAUBIGNY'S STUDIO BOAT
Determined to confront nature in the raw, Daubigny built lean-to huts to shelter him from the elements as he painted in the open air. In 1857, he even built himself a studio boat (*botin*), on which he could live and work. In this etching, he depicts himself painting in his *botin*.

Modern replica of Monet's studio boat

MONET'S FLOATING STUDIO
Following Daubigny's example, Monet had a floating studio built when he lived by the River Seine at Argenteuil, in the 1870s. But while Daubigny used his *botin* to take him to remote stretches of the river, staying on board for long periods, Monet rarely travelled far, and often moored to paint in the midst of local yachts.

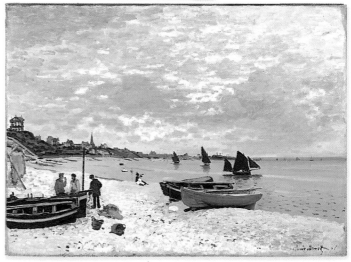

THE BEACH AT SAINTE-ADRESSE
Claude Monet; 1867; 75.8 x 102.5 cm (30 x 40½ in)
This Normandy beach scene, painted on the spot near Monet's family home, owes a debt to Boudin and Jongkind. Its sketchy, broken brushwork, bright colours, and modern subject matter anticipate Monet's mature Impressionist style of the 1870s. Indeed, it was shown at the second Impressionist exhibition.

Monet and the Seine

CLAUDE MONET
(1840–1926)
The son of a well-off businessman, Monet became a driving force in Impressionism.

Tʜɪs ɪs ᴏɴᴇ of the earliest recognisably "Impressionist" landscapes. Painted in the open air, in a few sittings at the most, with the broad, bright, slab-like patches of colour that characterize Monet's Impressionist style, its sketchy boldness is astonishing. The woman sitting by the river is Monet's future wife, Camille, but the picture is in no way a portrait of her: Monet's interest lies not in details, but in capturing the effect of the whole scene as it would be perceived in a momentary glance. The painting was displayed in the second Impressionist exhibition of 1876, eight years after it was executed.

A LATER SKETCH OF BENNECOURT
On the right-hand sketch, Monet has noted the time of day – "noon–1pm" – reflecting his interest in changing light conditions throughout the day.

Chrome yellow

Lead white

ARTIST'S PALETTE
Monet's palette probably includes chrome yellow, lead white, cobalt blue, emerald green, and viridian green.

Cobalt blue

Viridian green

Emerald green

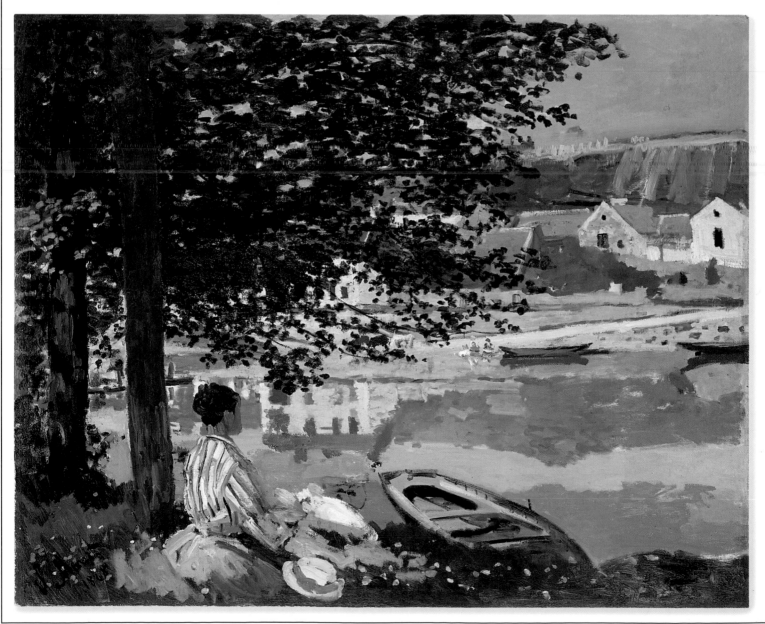

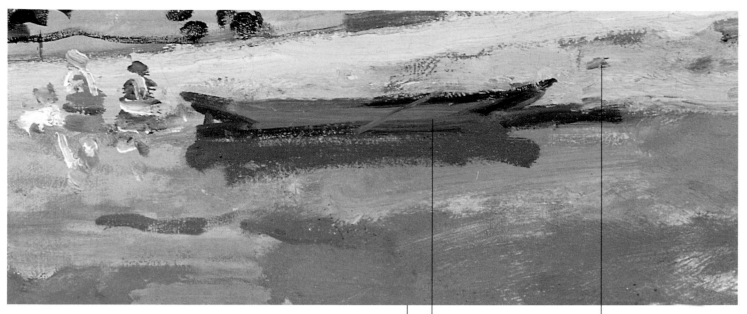

REFLECTIONS FROM THE SHORE

Throughout his painting career, one of Monet's main concerns was with capturing the fleeting effects of light on water. The impermanent reflections on the river's surface appear as substantial as any of the tangible elements of the painting. This detail shows the artist's varying technique: a few squiggles from a well-loaded, fine brush are used for the people, while wider, square-ended brushes create scrubbed areas and distinct, slab-like strokes.

A few individual strokes depict the boat and its reflection

Dots and dashes of green show grassy patches

Facial features are distinguishable beneath the roof reflections

SKY ON WATER

Concerned as much with the visual structure of the picture, as with capturing natural effects, Monet added this patch of bright blue reflection after painting the dark grass – deliberately creating a diagonal link with the sky at the top right.

ALTERED IMAGE

Monet clearly altered the composition as he worked, most drastically changing the area above the woman's lap. The existing figure replaced a frontal view of a woman; the original pinkish flesh tones of her face show through the cream and brown overpainting.

On the Seine at Bennecourt

CLAUDE MONET

1868; 81.5 x 100.7 cm (32 x 39½ in)

Painted in 1868, this image of Camille on a riverbank at Bennecourt was executed during a time of radical experimentation for Monet, as he rejected the highly finished surfaces and lofty themes of academic art. A rare surviving example of work from that period, it shows him creating a new visual language of bright, rapidly applied colour to capture open-air effects.

Long, rectangular strokes describe the trunk's mottled surface, but not its rounded form

HAT AND FLOWERS

Monet accentuates the informality of the scene by painting the yellow hat casually discarded on the flower-dotted grass. Broad brushstrokes depict the hat and its bright blue ribbon, while the "flowers" themselves are simply specks of yellow and white, dabbed on to the scrubbed green paint that indicates the grassy bank.

The Batignolles group

IF IMPRESSIONISM HAD A BIRTHPLACE, it was the Batignolles district of Paris. Many *avant-garde* artists and writers lived there, and from the late 1860s, Manet was at the centre of evening gatherings in the local Café Guerbois, where animated discussions on modern art took place. As well as a number of critics who supported Manet's controversial painting, younger artists such as Fantin-Latour, Degas, and Bazille (a family friend of Manet's) became Café Guerbois regulars. Bazille brought along friends he had met at Gleyre's studio – Monet, Renoir, and Sisley. Pissarro and Cézanne also came occasionally. But in July 1870, violent forces scattered the Batignolles group, as France embarked on a disastrous war with Prussia. Manet and Degas joined the National Guard, while Monet, Sisley, and Pissarro fled to England. Renoir was posted far from the fighting. But Bazille was less fortunate: he was killed in action at the age of 29.

THE PLACE DE CLICHY
Torn down and rebuilt by Baron Haussmann (p. 6), the Batignolles quarter epitomized the new Paris that would be associated with Impressionism. At its centre was the spacious Place de Clichy.

THE CAFE GUERBOIS
Edouard Manet; 1869; 29.5 x 39.5 cm (11¾ x 15½ in); pen and ink on paper
In the heart of the Batignolles quarter, near the Place de Clichy, the Café Guerbois was the site of many discussions on art. In this vivid pen-and-ink drawing, thought to be of the Guerbois, Manet has captured the atmosphere of an artists' café. Most evenings, and particularly on Thursdays, the group of Manet's friends and admirers included the novelist and journalist Emile Zola and progressive critics such as Zacharie Astruc, Edmond Duranty, and Théodore Duret. Manet was "overflowing with vivacity", but he did not like to be contradicted. After one heated discussion at the café, he even challenged Duranty to a duel. Duranty was wounded, but that evening they were friends again, and the café regulars composed a song in their honour.

EMILE ZOLA
Edouard Manet; 1867–68; 146.5 x 114 cm (57¾ x 45 in)
A boyhood friend of Cézanne's, Zola used his column in the daily newspaper *L'Evénement* to champion Manet and the "naturalists", as he called the future Impressionists. In 1868, he noted that "they form a group which grows daily. They are at the head of the [modern] movement in art."

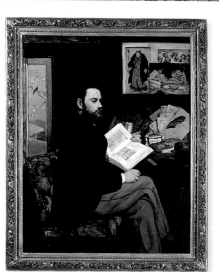

ZOLA'S DAMNING NOVEL
Zola's relationship with the Impressionists came to a bitter end in 1886, with his novel, *L'Oeuvre*. Its artist-hero – a mixture of Manet and Cézanne – dreams of greatness, but finds only failure.

A STUDIO IN THE BATIGNOLLES QUARTER
Henri Fantin-Latour; 1870; 204 x 273.5 cm (80¼ x 107¾ in)
Exhibited at the Salon of 1870, Fantin-Latour's formal homage to his friend, Manet, echoes his earlier tribute to Eugène Delacroix. The dapper Manet sits at his easel, painting a portrait of Astruc. Standing (left to right) are Otto Scholderer (a German Realist painter), Renoir, Zola, Edmond Maître (a musician friend of Bazille's), Bazille, and Monet.

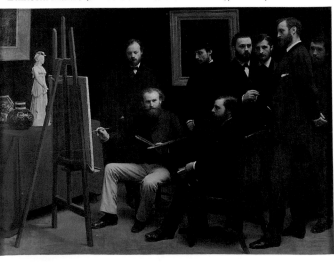

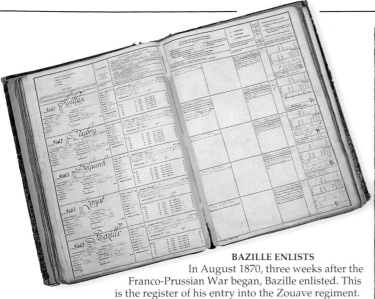

War and civil war

For the Impressionists, the greatest casualty of the war was Bazille. But there were other losses: Sisley's family business was ruined, and Pissarro returned to France to find that all but 40 of his 1,500 works had been destroyed when enemy troops requisitioned his house. Soon after France's defeat by the Prussians, civil war raged on the streets of Paris.

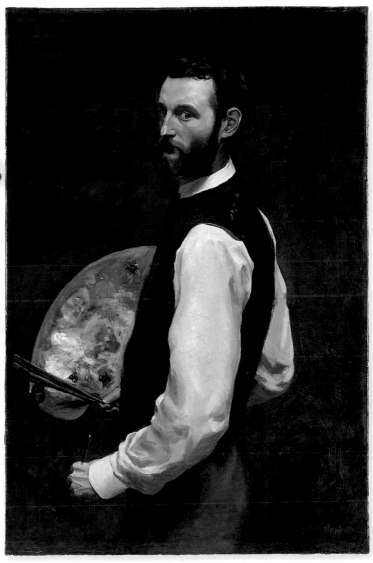

SELF-PORTRAIT
Frédéric Bazille; c.1865; 99 x 71.8 cm (39 x 28¼ in)
Five years after Bazille painted this stunning self-portrait, he was shot dead by a Prussian sniper. The gifted, generous young artist was deeply mourned by his friends.

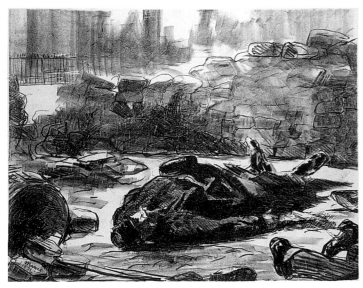

CIVIL WAR
Edouard Manet; c.1871;
39.5 x 50.5 cm (15½ x 20 in); lithograph
In March 1871, a radical, citizen-led regime, known as the Commune, set itself up against the French government at Versailles. The streets of Paris became a battleground, and more than 20,000 died in the intensely bloody civil war. Manet was in Paris for the last days of the Commune, and witnessed this scene. Composed some time after the event, the image of a dead Communard lying in the rain evokes the futility of war.

AT THE BARRICADES
Communards set up barricades to keep out government forces. But when the Versailles troops entered Paris in May 1871, thousands were slaughtered, even if they showed the white flag of surrender, as Manet's fallen soldier has done.

Barricade de la rue de Flandre, salle de la Marseillaise (18 mars 1871)

The Communard's medal: *"Le triangle de la Commune"*

COMMUNE RIFLE
Designed by Alphonse Chassepot in 1866, the Chassepot rifle was used extensively at the time of the Franco-Prussian War and the Paris Commune. A bayonet (left) was often fixed to the rifle.

17

Rebelling against the Salon

THE IMPRESSIONISTS BEGAN THEIR CAREERS at a time when being a successful artist meant achieving official success at the Salon, France's annual artistic showcase. The Salon encouraged, exhibited, and rewarded immaculately finished, conventional paintings, often with historical, religious, and mythological subject matter. There were exceptions, but the future Impressionists – with their sketchy technique, their concentration on modern landscapes, and apparently arbitrary views of contemporary Parisian life – were repeatedly rejected by the Salon jury. In 1874, they finally made a bid for independent recognition by boycotting the Salon, and putting on a privately organized show of their own. From April to May, 30 members of the newly formed "*Société Anonyme des Artistes Peintres, Graveurs*" exhibited in what became known as the first "Impressionist exhibition".

SALON DES REFUSES
When thousands of works were rejected by the Salon jury of 1863, there was an outcry. The Emperor decreed that all the rejected works of art should be shown at an alternative Salon – the Salon of the Rejected. This one-off show exposed the gap between official and new, more modern art.

THE SALON JURY
Henri Gervex; 1885; 299 x 419 cm (117¾ x 165 in)
The Salon had begun in the 17th century as an exhibition of works by members of the French Royal Academy. After the French Revolution, the exhibition was open to all artists, but works were selected by a jury. By the Impressionists' day, artists were allowed to sit on the jury – but only those artists who had already won a Salon medal. Not surprisingly, there was a self-perpetuating strain of conservatism among the selectors. This painting shows the Salon jury in 1885, voting with their umbrellas and canes for a provocative, but timeless and safely passive nude.

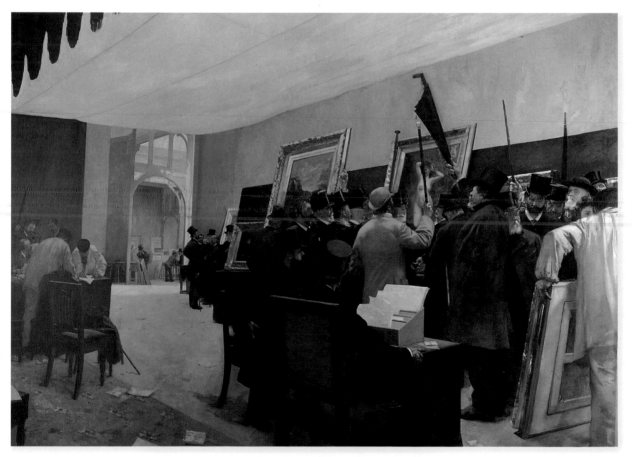

Scandal at the Salon

Manet's modern adaptations of 16th-century masterpieces caused uproar; the female nude in *Déjeuner sur l'Herbe* shocked the Salon des Refusés, and *Olympia* (left) scandalized the Salon of 1865.

OLYMPIA
Edouard Manet; 1863; 130.5 x 190 cm (51½ x 74¾ in)
"Abuses rain on me like hail," wrote Manet, when *Olympia* was exhibited. Today, it may appear no more shocking than the nude in Gervex' painting. But to viewers at the time, the image of a modern prostitute shamelessly returning their gaze defied the conventions enshrined by the Salon.

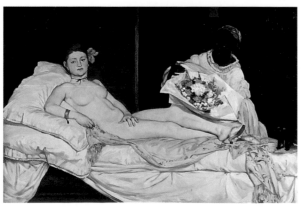

MOCKING REVIEWS
It was standard for Salon reviews to mock exhibits. Cartoonists focused on *Olympia's* gorilla-like "ugliness" – lampooned here – and on Manet's bold contrasts between light and shade.

NADAR'S STUDIO
The first show was held, in Paris, in the vacated studios of the celebrated photographer Nadar. He knew the group from the Café Guerbois (p. 24).

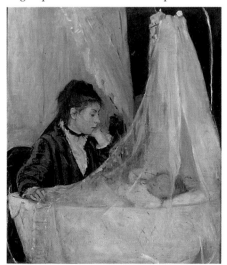

THE CRADLE
Berthe Morisot; 1872; 56 x 46 cm (22 x 18 in)
Morisot was the only female artist in the first exhibition. Her works included this broadly handled, yet delicate view of her sister, Edma, watching over her baby daughter.

CARTOON CRITICISM
One of many such attacks, this cartoon shows Impressionist works being used to scare an enemy.

TWILIGHT, WITH HAYSTACKS
Camille Pissarro; 1879; 10.3 x 18 cm (4 x 7 in); etching and aquatint
The Impressionists did not only show paintings in their exhibitions. For example, in the fifth show of 1880, Pissarro included several states of this superbly luminous print. It was printed in various colours – black, blue, brown, and red – as in this version printed by Degas. The colours reflected the way light changed through the day.

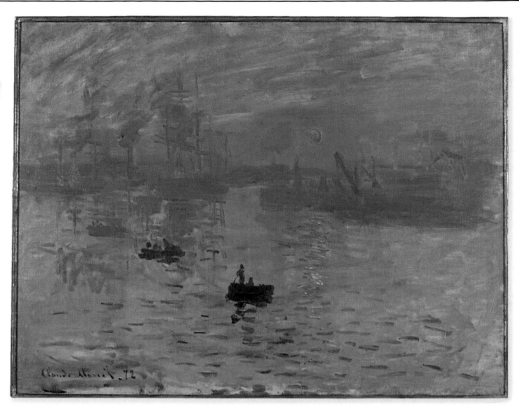

IMPRESSION, SUNRISE
Claude Monet; 1872; 48 x 63 cm (19 x 24¾ in)
Monet's choice of title for this sketchy view of Le Havre inadvertently led to the coining of the term Impressionism. "Impression," Louis Leroy wrote in the satirical journal, *Le Charivari*, "wallpaper in its embryonic state is more finished … ". The label was quickly adopted by others; within a year it became an accepted term in the art world.

Impressionist exhibitions

By the 1860s, the Salon's stranglehold on the art world was loosening: Manet showed his paintings in his own pavilion at the 1867 World Fair in Paris. In 1874, friends from the Café Guerbois held the first of eight group shows. They chose not to give themselves a name that would imply a group style, but they were soon given one. Seizing on the title of Monet's *Impression, Sunrise* (above), the critic Louis Leroy called his scathing review of their show, "Exhibition of the Impressionists".

"Printed by Degas"

A revolution in colour

IN THEIR USE OF COLOUR, the Impressionists made their most significant break away from academic tradition. Since their student days, they had admired the expressive colour in works by the Romantic master Eugène Delacroix (1798–1863). But working in the open air had focused their interest on the fleeting light effects and colours of nature, which could only be captured in a more shorthand technique than the laborious process of academic art; the Impressionists used a limited range of bold colours to recreate the world as they saw it. Their observation that the colours of objects were not "fixed", but were modified by their surroundings, was confirmed by scientific findings. In the mid-19th century, Eugène Chevreul had shown how powerful optical effects could be obtained by placing colours next to each other.

THE COLOURS OF THE SPECTRUM
In 1666, Sir Isaac Newton showed that white light could be split into many colours – the spectrum or rainbow – by a prism. He identified the colours of the spectrum as red, orange, yellow, green, blue, indigo, and violet. It became clear that there were three so-called primary colours – red, blue, and yellow – from which all the other colours could be mixed. By the 19th century, scientists understood that the human eye was sensitive to these three colours, and began to explore precisely how colours were perceived by the eye.

CHEVREUL'S COLOUR CIRCLE
Chevreul's "law of simultaneous contrast" – which states that when two colours are placed next to each other, the differences between them appear at their greatest formed the theoretical basis of Impressionist colour. Chevreul designed this circle to indicate the precise relationships between colours: those on the blue side are termed "cool" and appear to recede; those on the red side are "warm" and seem to advance.

COMPLEMENTARY PAIRS
The basic complementary pairs of colour are related to the primaries: each primary has a complementary created by mixing the other two. The eye perceives colour as surrounded by its complementary, and neighbouring complementaries create a vibrant effect, as in Monet's painting (right).

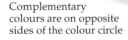
Complementary colours are on opposite sides of the colour circle

Chevreul's law of contrast
Chevreul first published his influential book, *On the Law of Simultaneous Contrast of Colours*, in 1839. It describes how neighbouring colours modify each other, the most intense effects occurring when complementaries (above right) are contrasted. Chevreul even advocated using coloured frames to heighten the colours in a painting, an idea favoured by the Impressionist artists, but not by their dealers or buyers.

DELACROIX'S PALETTE
By mixing his colours with white, as he has done here, Delacroix increased the overall brightness of his paintings. His revolutionary use of colour inspired the Impressionist artists. He used colour to indicate shadows, as they were to do, rather than adding black.

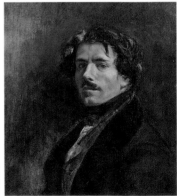

SELF-PORTRAIT
Eugène Delacroix; c.1837; 65 x 54.5 cm (25½ x 21½ in)
The supreme colourist of his day, and the Impressionists' idol, Delacroix also knew of Chevreul's work. He made stunning use of complementary contrasts, and banned "earth colours" – iron oxide pigments of dull reds, yellows, and browns – from his palette.

FROM TAPESTRY TO PAINTING

A distinguished chemist, Chevreul was the director of dyeing at the Gobelins tapestry factory in Paris. Investigating why some colours in tapestries such as this looked duller than others, he discovered that a colour looked more or less bright depending on the colours surrounding it. The Impressionists exploited the effects of "simultaneous contrast" in the colouring of many of their works.

COLOUR MERCHANTS

The Impressionist use of bright colour was partly made possible by the rapid development of paint technology in the 19th century. A wider range of pigments became available, ready ground and in easily portable tubes (p. 13). These were sold by colour merchants such as this one, pictured in about 1900.

REGATTA AT ARGENTEUIL

Claude Monet; 1872; 48 x 75 cm (19 x 29½ in)
In this rapidly executed river scene, Monet has made powerful use of the "law of simultaneous contrast" to reflect the scintillating effects of light on water. The most intense contrasts are between the complementary pairs red-green and blue-orange. Monet has also used subtle contrasts, such as the red-orange of the boathouses.

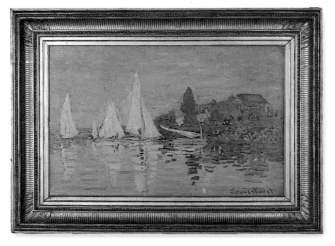

SLABS OF COLOUR

To capture the ever-changing light effects they observed in nature, the Impressionists adopted a shorthand technique; applying paint in individual, contrasting slabs of bright colour, as Monet has done here to indicate reflections.

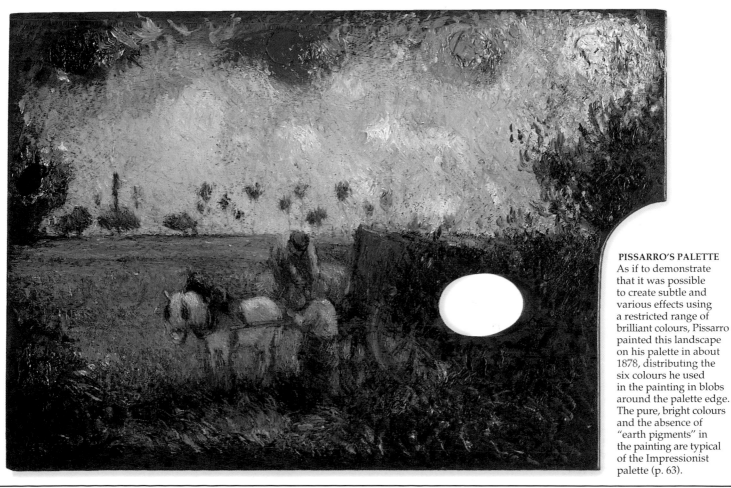

PISSARRO'S PALETTE

As if to demonstrate that it was possible to create subtle and various effects using a restricted range of brilliant colours, Pissarro painted this landscape on his palette in about 1878, distributing the six colours he used in the painting in blobs around the palette edge. The pure, bright colours and the absence of "earth pigments" in the painting are typical of the Impressionist palette (p. 63).

The Impressionist palette

RENOIR WAS ONE OF THE MOST brilliant colourists in the Impressionist group. As a teenager, he had been apprenticed as a porcelain painter, and in the ceramics workshop he had learned how to use the most pure and vibrant colours to achieve his effects. Just as a white porcelain base accentuated the clarity and brilliance of painted colour, so Renoir knew that a canvas primed (p. 63) with white or cream made the pigments appear lighter and brighter. Like his fellow Impressionists, he rejected painting on traditional dark grounds in favour of very pale or white grounds. The colouring of *Two Sisters* is based on Renoir's visual sense and intuition rather than on theory. Yet it is almost a textbook example of how the Impressionist artists used Chevreul's "law of simultaneous contrast" (pp. 20–21) in their painting techniques.

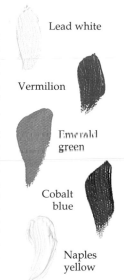

DECORATIVE INSPIRATION
Since his early training as a porcelain painter, Renoir always loved 18th-century decorative art, and particularly works by François Boucher. This exquisite porcelain by Boucher shows the vivid effect of pure, clear colours on a white base that inspired the young Renoir.

ARTIST'S PALETTE
Like the other Impressionists, Renoir generally restricted his palette to a limited number of pure, rather than mixed, colours. Analysis at the Art Institute of Chicago has identified the following pigments – lead white, vermilion, emerald green, cobalt blue, Naples yellow, crimson lake, and ultramarine blue – and the use of lead white priming.

Lead white

Vermilion

Emerald green

Cobalt blue

Naples yellow

Two Sisters
AUGUSTE RENOIR
1881; 100.5 x 81 cm (39½ x 32 in)
This charming, almost life-size picture was probably painted at Chatou, a riverside resort outside Paris, where Renoir spent the spring of 1881, "struggling with trees ... women, and children". The artist has used the terrace balustrade to divide the picture space into foreground and background. While the most intense colours have been used to depict the foreground figures, the colours are diluted in the distance. To avoid overmixing, and so retain the purity of his colours, Renoir mixed his paints on the canvas rather than on the palette, and applied them wet-in-wet – adding colours next to or into another, before the first is dry.

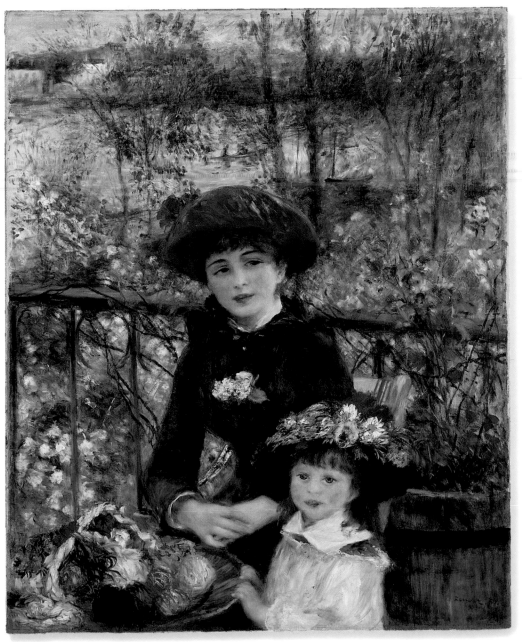

Thick impasto *strokes are applied wet-in-wet*

FACE AND FLOWERS
Renoir tended to thin his colours more than the other Impressionist artists, applying paint in smooth, feathery brushstrokes. This delicate technique, which allows the white ground to shine through, is used for the girl's translucent pale skin and blue eyes. In contrast, her vivid hat is painted in bold, *impasto* colours, in a virtuoso display of Renoir's flower painting skills.

Bright green, made from a mixture of Naples yellow and emerald green

GREEN ON RED
"I want my red to sound like a bell," Renoir said. "If I don't manage it at first, I put in more red, and also other colours, until I've got it ... I haven't any rules or methods." He may not have used any rules, but his understanding of the law of complementary colour contrast (pp. 20–21), of how placing colours next to each other altered their appearance, is clearly illustrated in this detail. The blazing red of the older sister's hat is intensified by the bright flash of the green leaves attached to it. The bright red of the hat is also echoed throughout the picture – in the balls of yarn, the large red flower in the little girl's hat, and the thin ribbon running between the older sister's waist and arm.

MODELLING THE HANDS
The hands are built up from thin, fluid layers of paint, applied wet-in-wet with a very fine brush. Renoir makes subtle use of the visual effects of warm and cool colours (p. 20) to model the form of the hands – the warm pinks and gold appear to advance, while the cool blue shadows recede.

COLOURED YARNS
The boldly painted balls of yarn in the basket seem to represent the range of basic colours from which the picture was painted, and the typical Impressionist palette. The complementaries red and green feature again, but the red is purer and less mixed than that of the hat. Strands of lead white are clearly visible in the balls of pink and red yarn. Contrasting in both texture and colour with the surrounding areas, these confidently applied, individual strands of paint are the physical equivalents of the actual lengths of yarn.

Caillebotte's Paris

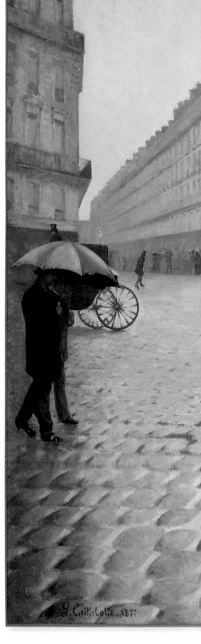

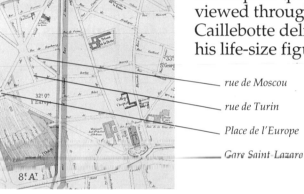

GUSTAVE CAILLEBOTTE
(1848–1894)
The hugely wealthy Caillebotte has unjustly been remembered only as a collector. He was also a distinctive artist, who began exhibiting with the Impressionists in the second group exhibition of 1876.

THIS MONUMENTAL PAINTING dominated the third Impressionist exhibition of 1877. Yet its tightly painted surface, sombre tones, and huge scale appear to be at odds with the small scale, bright colours, and broken brushwork usually associated with Impressionism. Contemporary critics acknowledged the difference: "Caillebotte is an Impressionist in name only. He knows how to draw, and paints more seriously than his friends," one wrote. Caillebotte's methods may differ from his fellow artists, but he has created one of the most arresting Impressionist images of modern life – both a celebration and a critique of the brutal, dehumanizing geometry of Haussmann's urban plan (p. 6). Presenting the scene as if viewed through a wide-angle camera lens, Caillebotte deliberately distorted perspective; his life-size figures loom towards the viewer.

rue de Moscou

rue de Turin

Place de l'Europe

Gare Saint-Lazare

INTERSECTING STREETS
This map of the Batignolles area from Haussmann's atlas shows how the rue de Turin and the rue de Moscou, where *Paris, a Rainy Day* is set, meet at a wide intersection. Saint-Lazare station and the Pont de l'Europe nearby were also painted by Caillebotte (p. 33).

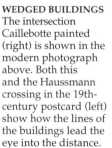

WEDGED BUILDINGS
The intersection Caillebotte painted (right) is shown in the modern photograph above. Both this and the Haussmann crossing in the 19th-century postcard (left) show how the lines of the buildings lead the eye into the distance.

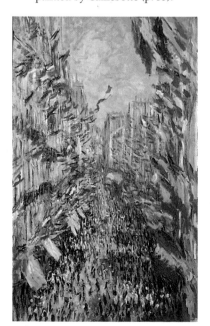

RUE MONTORGEUIL, PARIS
Claude Monet; 1878; 81 x 50.5 cm (32 x 20 in)
Where Caillebotte has frozen a random moment, stressed the geometry of the new Paris, and constructed his painting in stages, Monet's image of a street decked out with flags for a national festival was painted on the spot. Bright flags, and the flicks of paint indicating swarming crowds, obliterate the lines of the architecture and create a vivid sense of movement.

OIL SKETCH OF PARIS, A RAINY DAY
Gustave Caillebotte; 1877; 54 x 65 cm (21¼ x 25½ in)
This oil sketch represents a late stage of Caillebotte's planning of his huge painting. He began with a freehand sketch, perhaps based on a photograph, on which he overlaid ruled perspective lines, and drew in zigzag lines to indicate the positioning of figures. Detailed architectural and perspectival studies, drawings, and oil sketches preceded the final composition.

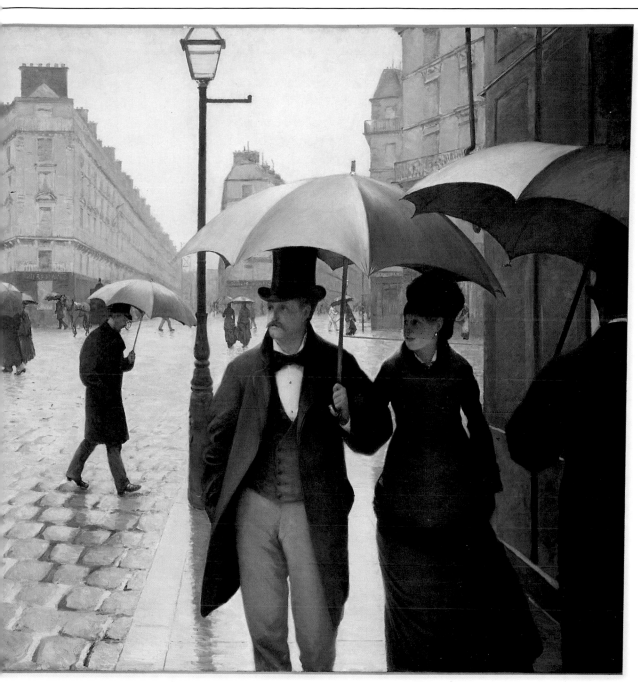

Paris, a Rainy Day
GUSTAVE CAILLEBOTTE
1876–77; 212.2 x 276.2 cm (83½ x 108¾ in)

Despite the apparent randomness of the image – the right-hand figure is deliberately cut in half to suggest the spontaneous, snapshot nature of the picture – Caillebotte's masterpiece is meticulously planned and ordered. The most obvious element of the linear framework is the positioning of the lamp-post, which cuts the canvas in half. It forms a cross with the horizon, creating four quadrants. A complex system of proportional relationships exists throughout the painting: the position of each figure was plotted at a significant point in the perspective plan.

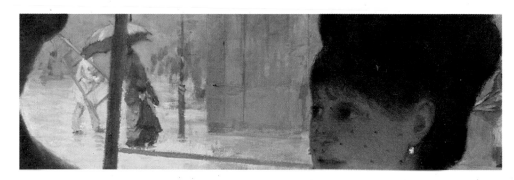

DISTANT DETAIL
What seem to be chance juxtapositions, created by elements overlapping in space, were carefully planned. Between the heads of the couple in the foreground, a house-painter and a woman step on to the distant pavement. In a deliberate clash of scales, the broad umbrella handle bisects this tiny scene, tying foreground and background together as it does so.

EXQUISITE CLOSE-UP
The highly finished surface of Caillebotte's painting, which had more in common with the technique of Salon artists than with that of the Impressionists, can be seen in the treatment of the foreground woman. A delicately painted, dotted black veil covers her face to her mouth. Behind it, a pearl earring glistens with Vermeer-like clarity.

The age of the train

Postcards of Argenteuil

ROUTE TO THE SUBURBS
As the timetable shows, the riverside suburb of Argenteuil was just a 15 minute rail journey from Saint-Lazare. It became the most important centre for Impressionism, besides Paris, during the 1870s.

THERE WAS NO MORE AGGRESSIVE SYMBOL of modernity than the new railways, which had transformed society in the Impressionists' lifetimes. Six stations served Paris, but it is Gare Saint-Lazare that is most closely associated with Impressionism. The appeal of Saint-Lazare, which also inspired writers such as Zola, was understandable. It occupied a vast area in the Batignolles district (p. 16), where the Impressionist artists had originally grouped. Thirteen million passengers a year poured through it into the city – most from the suburbs, which had now become accessible to Parisian worker, tourist, and artist alike. Not only was Saint-Lazare at the centre of the artists' modern urban world, it was their link to the countryside. Many suburban sites that feature in Impressionist art – Bougival, Marly, Argenteuil, Pontoise, and Auvers – were reached from there. The station was a central motif at the third Impressionist show of 1877; both Monet and Caillebotte showed pictures set at Saint-Lazare (below; right).

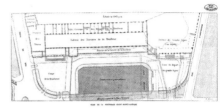

GARE SAINT-LAZARE
The newly built Saint-Lazare inspired both artists and writers. Zola wrote in great detail of the station, and of the general impact of the railways, in his hugely popular novel of 1879, *La Bête Humaine*.

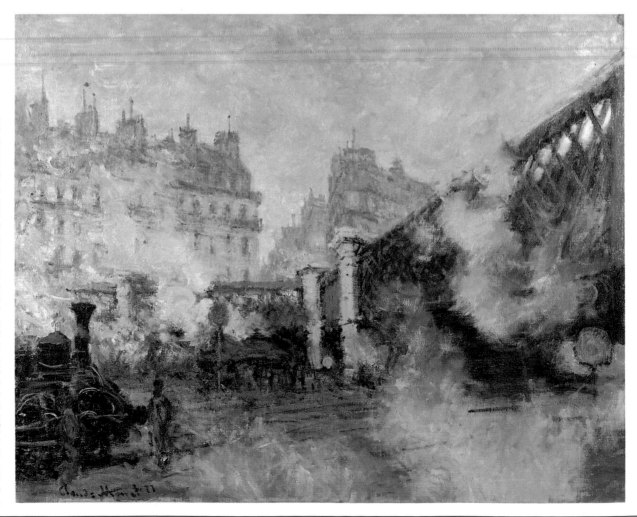

LE PONT DE L'EUROPE, GARE SAINT-LAZARE
Claude Monet; 1877; 64 x 81 cm (25¼ x 32 in)
Monet displayed seven paintings of Saint-Lazare at the 1877 exhibition. For this canvas, he painted the view from the edge of a platform looking towards the Pont de l'Europe, the new bridge that spanned the railway tracks. The roofs and chimneys of Haussmann's new apartment buildings appear, set against an overcast sky. As in Caillebotte's painting, the distinctive, dark trellis of the bridge bursts into the picture from the right. Monet has softened its harsh lines with clouds of steam, depicted by rapid strokes of light grey and white paint. These stand out against the dark masses of the bridge and trains.

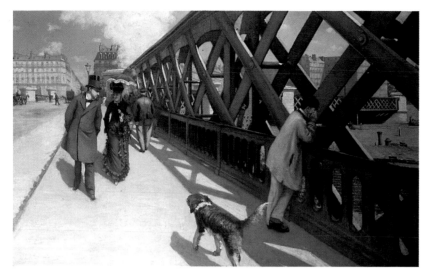

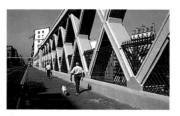

LE PONT DE L'EUROPE
Gustave Caillebotte; 1876; 131 x 181 cm (51½ x 71¼ in)
While Monet painted his railway pictures on the spot, Caillebotte's image of the bridge was, like *Paris, a Rainy Day* (pp. 30–31), the result of numerous studies. As in that painting, Caillebotte uses a funnel-like space that recedes dramatically, and carefully positions his figures (and, in this case, a dog) within a precise, architectural framework. The converging perspective lines come together in the head of the top-hatted man, who is thought to be a self-portrait. If so, Caillebotte has made himself the focus of the composition, and a *flâneur* – an artist-dandy who observes life with sophisticated detachment. Nearby, a manual worker stares through the girders.

VIEW FROM UPPER NORWOOD
Camille Pissarro; c.1870; ink and pencil on paper
In this sketch from Upper Norwood, London, Pissarro places the train in the middle distance as it is in his painting (right), but here it is viewed from the side, and almost obscured by trees. The inclusion of the train and factories adds an aspect of industrial modernity to an otherwise rural landscape.

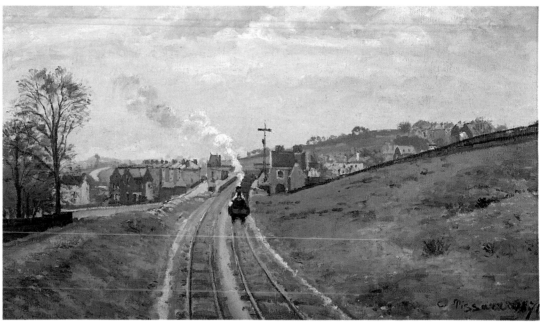

LORDSHIP LANE STATION, DULWICH
Camille Pissarro; 1871; 45 x 74 cm (17¾ x 29 in)
Like Paris, London was transformed by the railways in the 19th century. Suburbs such as Lower Norwood, where Pissarro stayed from 1870 to 1871 to escape the Franco-Prussian War, had been newly linked by rail to the city; Lordship Lane station, pictured above, was only six years old. Pissarro places the track centrally: its converging lines lead the eye into the painting. The train heads directly towards us, yet its position in the middle distance removes any sense of drama or danger.

THE RUSH TO THE COUNTRY
This late 19th-century illustration shows enthusiastic middle-class Parisians joining a crowded double-decker steam train, as it waits to take them for a Sunday in the country. With the new network of suburban railway lines, previously remote countryside and the attractive, leafy suburbs outside Paris were within easy reach to all classes.

TRAIN IN THE COUNTRYSIDE
Claude Monet; c.1870–71; 50 x 65 cm (19¾ x 25½ in)
Puffing along behind a bank of trees, a double-decker train carries tourists on the Paris to Saint-Germain-en-Laye line, while weekenders promenade on the grassy slopes of a country park. In this little painting, Monet creates a vivid image of the way in which the train brought the city and countryside together.

Days at the races

MAP OF THE BOIS
The Longchamp racetrack was located in the Bois de Boulogne, just ten kilometres (six miles) from the city centre. It was also in easy reach of the upper-class residents of Paris' fashionable western suburbs.

HORSE RACING WAS the most fashionable spectator sport of Parisian high society in the Impressionists' day. Imported from England in the 1830s, its popularity was bound up with a craze for everything English that gripped the French upper classes. As part of the Emperor's plans for his modern capital, the new Longchamp racetrack had been completed in 1857 in the Bois de Boulogne, on the outskirts of the city. But this aspect of Parisian life was ignored by most of the Impressionists: the racetrack appears only in the work of Manet and Degas, who both disassociated themselves from "mainstream" Impressionism. While Manet made only a few images of the turf, focusing on the drama and social spectacle of the race, in Degas' art the movement of the racehorse was a major theme.

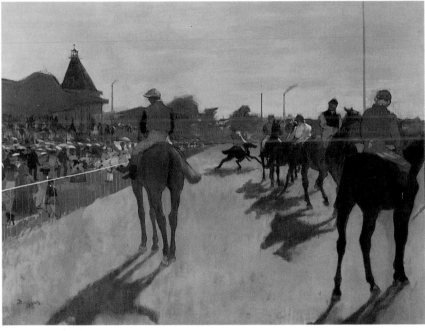

JOCKEYS IN FRONT OF THE STANDS
Edgar Degas; c.1866–68;
46 x 61 cm (18 x 24 in)
Degas preferred to depict the moments before the race began, when the individual movements of the horses could be seen most clearly. Where Manet evokes speed in a painterly blur of action, Degas' draughtsmanship shows the horses' *potential* for speed. Like Japanese artists (pp. 54–55), he has created a flat pattern on the canvas, setting the contours of the horses against the pale triangle of the receding racetrack.

The Races at Longchamp
EDOUARD MANET
c.1864; 43.9 x 84.5 cm (17¼ x 33¼ in)
Manet's stunning painting captures the drama of a race at Longchamp, as the closely grouped horses gallop past the finishing post, directly towards the viewer. This dangerously involving, head-on view is thought to be the first of its kind in the history of art. The precise geometry of the finishing post, cut through by the distant horizon, emphasizes the great speed of the horses, as their thundering hooves disappear in a trail of dust. With his virtuoso shorthand technique, Manet has reduced the elegant crowd to an animated mass of dots – only a few figures stand out as individuals.

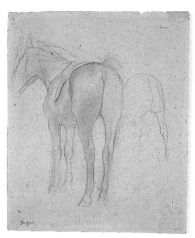

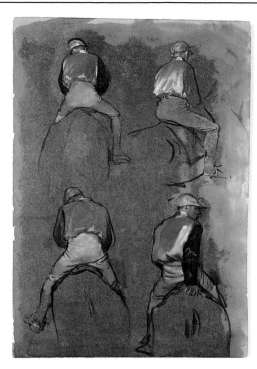

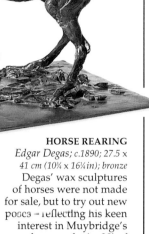

STUDIES OF A HORSE
Edgar Degas; c.1868–70; 30.5 x 24.4 cm
(12 x 9½ in); graphite on paper
Degas produced 45 paintings, 20 pastels, some 250 drawings, and 17 sculptures on the racehorse theme. He constructed the finished images in his studio, taking poses from his stock of studies, such as this back view. It may be related to the left-hand horse in his canvas (far left).

FOUR SKETCHES OF A MOUNTED JOCKEY
Edgar Degas; 1866;
45.3 x 31.6 cm (17¾ x 12½ in);
gouache, ink, and oil on paper
In this superb study, Degas uses gouache, ink, and oil paint to explore the way the sheen of the jockey's silks changes as he moves.

HORSE REARING
Edgar Degas; c.1890; 27.5 x
41 cm (10¾ x 16¼ in); bronze
Degas' wax sculptures of horses were not made for sale, but to try out new poses – reflecting his keen interest in Muybridge's photographs (p. 28) of horses in motion. They were later cast in bronze.

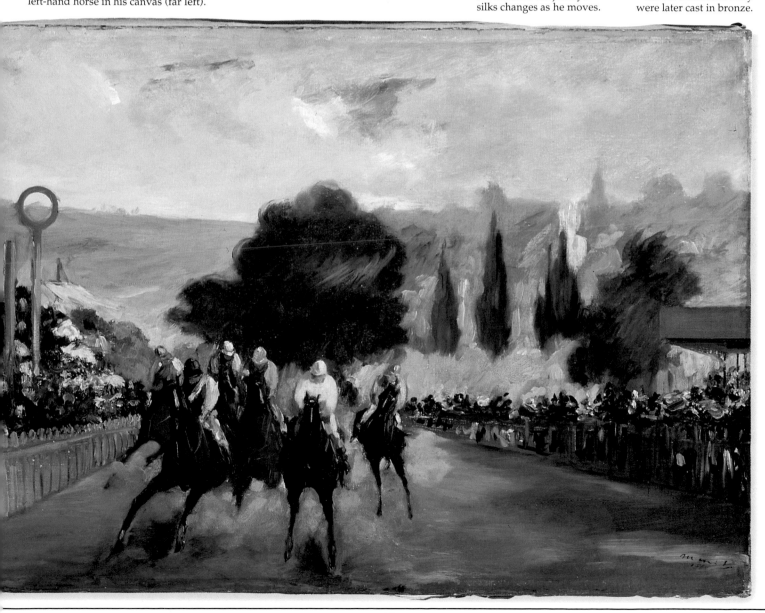

At the theatre

ELEGANT FAN
At the theatre, a fan was both a fashion item and a practical necessity.

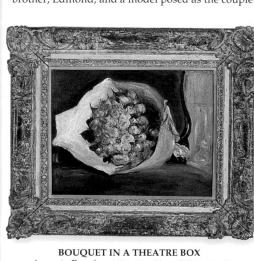

THE PARIS OPERA
Designed by the architect Charles Garnier to be one of the crowning glories of modern Paris, the magnificent Opéra was completed in 1875.

A CLOSER VIEW
Binoculars such as these were used by both male and female spectators for close-up views of the stage and audience.

IN THE 1870S PARIS was the theatrical capital of Europe. Like the café-concerts that spread through the city (p. 24), opera houses and theatres were crowded nightly. Some were grander than others, but most had rows of boxes and balconies (*loges*) that presented obvious pictorial framing devices. The stalls, which offered no such compositional framework, do not feature in Impressionist art. Isolated in their expensive loges, the elegant audiences, particularly the women, were part of the theatrical spectacle. The male escort usually sat behind his partner, so that she could be shown to her best advantage, as in Renoir's *La Loge*. Like Renoir, Cassatt focused on the audience, while Degas' interest was in the ballet dancers who performed on stage.

LA LOGE
Auguste Renoir; 1874; 80 x 63.5 cm (31½ x 25 in)
One of the best-loved Impressionist images, this painting even escaped criticism when shown at the first Impressionist exhibition. The woman in her splendid dress rests her opera glasses on the velvet ledge of the box, as she returns the viewer's gaze – not in the challenging manner of Manet's *Olympia* (p. 18), but as if acknowledging admiration. Theatre boxes were places both to see and be seen, and her male companion has raised his binoculars to observe the audience, rather than the stage. This social world was not frequented by the working-class Renoir: his brother, Edmond, and a model posed as the couple.

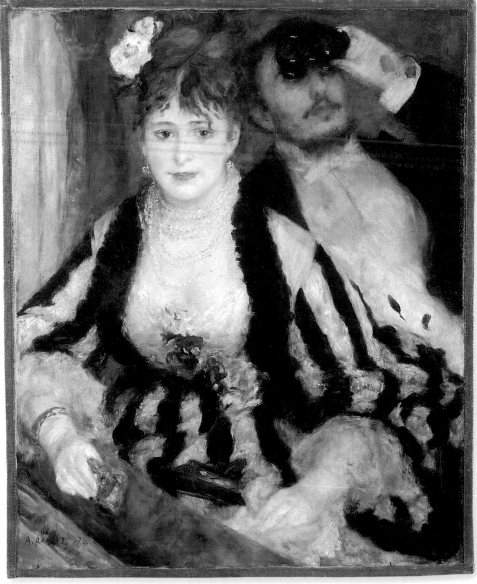

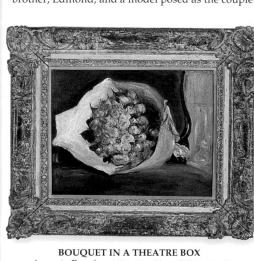

BOUQUET IN A THEATRE BOX
Auguste Renoir; c.1871; 40 x 51 cm (15¾ x 20 in)
In this unusual still life, Renoir has painted a posy of rosebuds lying on a pink velvet theatre-box chair. Posies, wrapped in white paper, were common fashion accessories carried by women at the theatre and opera, often given to them by their male escort. Although contextual references have been removed, this bouquet clearly belongs to Impressionist Paris.

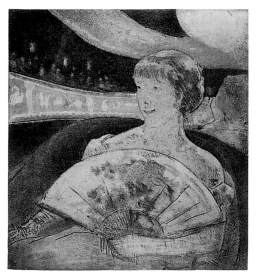

IN THE OPERA BOX
*Mary Cassatt; c.1880; 34 x 26.7 cm
(13½ x 10½ in); etching and aquatint*
Cassatt tackled similar compositions in oils, pastels,
and prints: this etching echoes the painting below.

Cassatt and Degas

At the invitation of Degas, the American
artist Mary Cassatt first exhibited with
the Impressionists in the fourth show of
1879, showing at least three pictures of
young women in theatre boxes. The
artist and critic Diego Martelli noted
that in her modern sense of movement,
light, and design, she might be a student
of Degas. Indeed, she later wrote, "The
first sight of Degas' pictures was the
turning point in my artistic life."

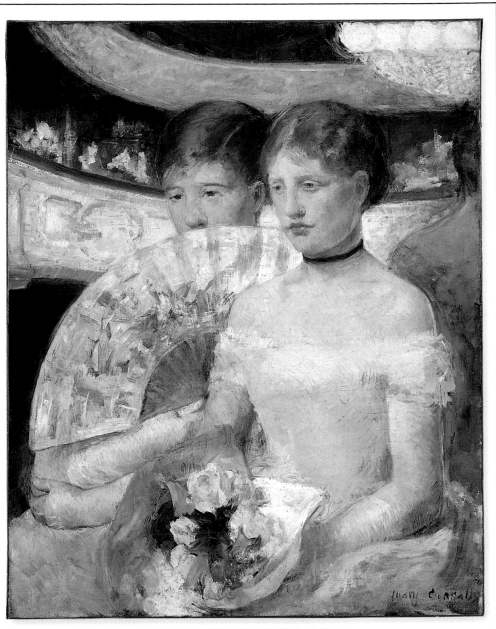

TWO YOUNG WOMEN IN A LOGE
Mary Cassatt; 1882; 80 x 64 cm (31½ x 25 in)
As in *Woman in a Loge* and *In the Opera Box* (left), Cassatt has used the pictorial format of
half-length sitters in the foreground, with reflections – of a shoulder and sweeping tiers of
balconies and boxes – in the mirror behind. But unlike the smiling, relaxed demeanour of
the women in the earlier images, these two well-bred young ladies (modelled by Geneviève
Mallarmé, daughter of the Symbolist poet, and an American visitor) appear stiff and self-
conscious about the idea of being on public view. One shields her face protectively behind
her colourful fan, whose semi-circular shape dominates the composition. Its line carries on
through her elbow and hand, and along her companion's shoulder, continuing through the
curve of the posy – suggesting a complete circle that binds the two young sitters together.

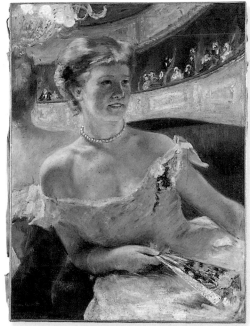

WOMAN IN A LOGE
Mary Cassatt; 1879; 80.3 x 58.4 cm (31½ x 23 in)
Originally set in a green frame, this painting was
singled out for lavish praise at the 1879 exhibition:
reviewers focused on the lighting and reflections.
It probably shows Cassatt's sister, Lydia.

**BALLET AT THE
PARIS OPERA**
*Edgar Degas; 1876–77;
36 x 72 cm (14 x 28½ in);
pastel over monotype*
While Renoir and
Cassatt pictured
spectators, Degas
chose to focus on
the performers. His
earliest ballet pictures
are viewed as if from
the orchestra pit, as
in this striking two-
tiered composition.

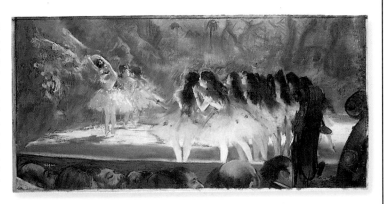

Degas' dancers

**EDGAR DEGAS
(1834–1917)**
Although he was a prime force in the Impressionist shows, Degas never thought of himself as an Impressionist. He was an outsider, stylistically and socially, until his friendship with Mary Cassatt (p. 51).

"THEY CALL ME the painter of dancers," Degas is reported to have said, "without understanding that for me the dancer has been the pretext for painting beautiful fabrics and rendering movement." Over half of his pastels and oils depict the ballerinas who performed between the acts at the Paris Opéra. From the 1870s, he drew and painted them obsessively, on stage, in their dressing rooms, in rehearsal, and at rest. Intimate, behind-the-scenes subjects far outnumber the images showing the dancers in performance. However, these intimate images are also impersonal: Degas scrutinized and documented the movements of the little "rats" – the adolescent dancers of the *corps de ballet* – with detachment. The modern, realist equivalent of the classical nude, they posed for him repeatedly in his studio. Degas was also intrigued by the social world backstage at the Opéra, where rich and powerful male "protectors" of the young dancers hovered and prowled in dressing rooms and in the wings.

DANCER STRETCHING AT THE BAR
Edgar Degas; c.1877–80; 31.8 x 24 cm (12½ x 9½ in); pastel
The presence of the bar implies that Degas made this pastel in a rehearsal room, but he preferred dancers to model in his studio. This pose has not been found in any of his paintings, and Degas' signature indicates that it is a finished work.

LITTLE DANCER AGED 14
*Edgar Degas; 1881;
98.4 x 42 cm (39 x 16½ in); bronze*
The original wax sculpture from which this bronze was cast shocked and impressed critics at the sixth Impressionist exhibition of 1881. Degas had taken realism to its extreme by dressing the figure in a real tutu and a silk ribbon

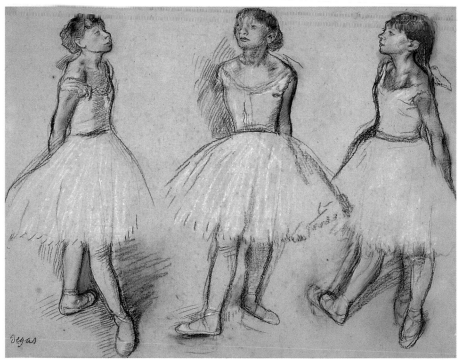

NUDE STUDY FOR THE DANCER
Edgar Degas; c.1878–79; 72.4 cm (29 in); bronze
Sketches (above) and this nude statuette preceded the final sculpture. Degas' use of real clothes rendered his work "thoroughly modern".

THREE STUDIES OF A DANCER IN FOURTH POSITION
Edgar Degas; c.1879–80; 48 x 61.5 cm (19 x 24 in); pastel
Degas' little dancer has been identified as the Belgian ballerina Marie van Goethan. For this large-scale charcoal and pastel study, Degas viewed his model in a fourth position pose from three angles, in preparation for the final sculpture.

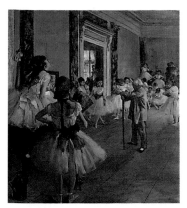

THE DANCE CLASS
Edgar Degas; c.1873–76;
85 x 75 cm (33½ x 29½ in)
Degas' composition
of a rehearsal with the
famed choreographer
Jules Perrot underwent
many revisions.

BALLET MASTER
Edgar Degas; 1874;
44.9 x 26.1 cm (17¾ x
10¼ in); crayon on paper
This may be a sketch for
a figure found beneath
Perrot in an x-ray of
the painting (left).

The Curtain

EDGAR DEGAS *c.1880; 27.3 x 32.4 cm*
(10¾ x 12¾ in); pastel over monotype

As the curtain hovers above the stage, and a dancer
flits past him and out of the frame, a top-hatted "lion"
– as the men who roamed backstage at the Opéra
were known – surveys the scene with proprietorial
nonchalance. Half-hidden by scenery, two other
lions wait in the wings, attracted less by the ballet
than by the ballerinas. Affairs between the dancers
and powerful men were a fact of Parisian life. Rich
subscribers enjoyed privileges, including the right
to stand in the wings during a performance, as here.

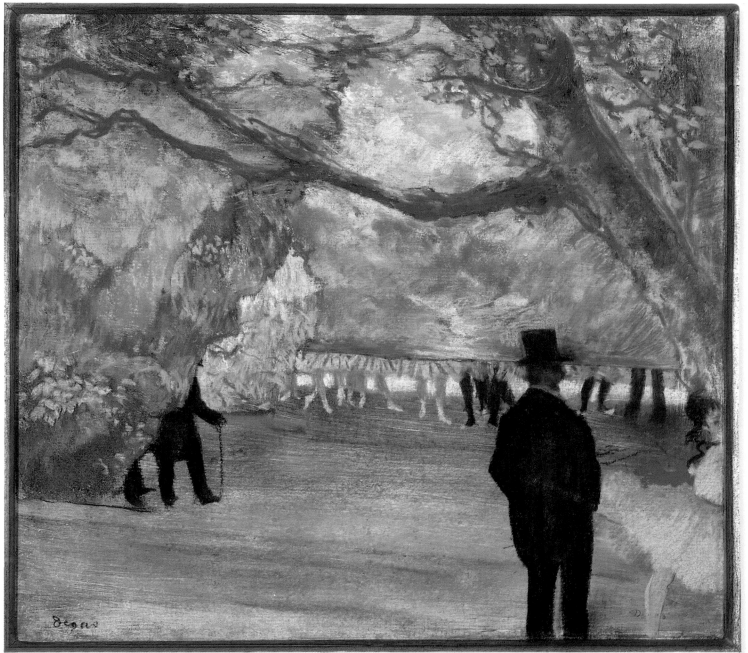

STAGE SCENERY
Degas' admiration for
the bold style of Japanese prints
(pp. 54–55) is evident in the way
the composition is dominated by
decorative scenery, that cuts off his
figures and creates unusual views.

EMPTY CENTRE
One of the striking elements of
the composition is the fact that the
central area, traditionally the focus
of interest, consists of the bare, empty
boards of the stage. The "action" is
pushed to the sides and background.

LEGS REVEALED
Compositional originality is
combined with a mocking sense of
humour. Just as the two lions emerge
from the wings in a ridiculously
incomplete silhouette, ballerinas'
legs seem to dangle from the curtain.

EXPRESSIVE BACK VIEW
Degas captured the essence of
a pose even from behind, as in the
main figure. He was drawn over the
dancer's trailing leg: the flash of her
red ribbon, and her full, white tutu,
emphasize his sinister darkness.

Inspired by Japan

JAPANESE WOODBLOCK PRINTS were first seen in France in the 1850s, and soon became immensely popular. Many of the Impressionists had collected these prints, known as *ukiyo-e* ("images of the floating world"), since the days of the Batignolles group (p. 16), when they were labelled the "Japanese of painting". The prints both inspired and confirmed the Impressionists' own ideas about colour and form, revealing a very different approach to composition from that of the Western tradition. Japanese artists combined areas of solid colour with stylized outlines, emphasizing the surface pattern of the print, rather than the illusion of space beyond the picture plane (p. 63). While European artists created a sense of space and depth using perspective, Japanese printmakers implied spatial relationships by placing one object behind another in overlapping planes. In the absence of a single point of focus, the viewer's eye was encouraged to wander over the flat, decorative surface. The prints' striking designs often included unusual viewpoints and figures cut off by the edge of the picture, echoing the effects of snapshots (pp. 28–29), and inspiring many Impressionist compositions.

Embroidered Japanese kimono, similar to that worn by Camille Monet (left)

THE JAPANESE CRAZE
Japan had been closed to the West until the 1850s, when new trading agreements brought its artefacts into Europe. When *Le Porte Chinoise* shop opened in Paris in 1862, selling items such as fans, prints, and kimonos, it found keen customers among artists. Not only inspired by Japanese art, they also used oriental objects as props in their work.

LA JAPONAISE
Claude Monet; 1876;
231.6 x 142.3 cm (91¼ x 56 in)
This contrived, rather vulgar image of Camille, Monet's wife, dressed in a blonde wig and embroidered kimono, was a huge success at the second Impressionist show. Monet later described it as "trash". The real Japanese influence on his art was far more subtle.

ROCKS AT BO-NO-URA
Ando Hiroshige;
c.1853–56; woodblock print
One of the many Japanese prints in Monet's collection, this seascape by the 19th-century master Hiroshige reveals the qualities of bold colour and strong design that appealed to the Impressionists. The sky and sea are shown in a triple band of flat colour, on which precisely outlined forms of rocks and boats have been positioned. The rectangles of the traditional signature boxes emphasize the sense of a two-dimensional surface pattern.

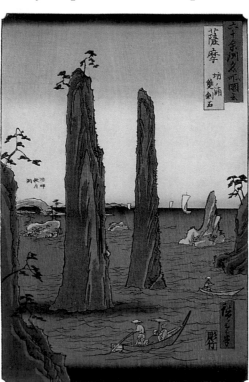

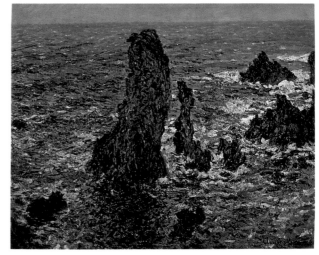

ROCKS AT BELLE-ILE
Claude Monet; 1886; 65 x 80 cm (25½ x 31½ in)
The subject matter of this painting, showing the Needle rocks in Brittany, has obvious links with Hiroshige's print (left). But it is Monet's way of depicting the scene that shows his assimilation of the formal language of Japanese art. Marrying naturalism with decoration, he evokes the choppy sea and barbed rocks with vigorous brushwork, at the same time creating a powerful pattern by setting the dark shapes of the rocks against a blue backdrop.

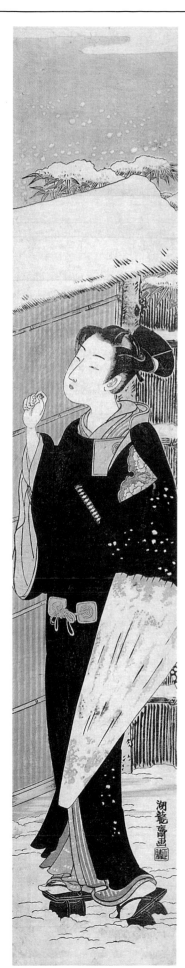

THE STRANGER AT THE GATE

Isoda Koryusai;
1771; pillar print

Narrow, elongated pillar prints (*hashirakake*) such as this were designed to decorate the wooden pillars of Japanese houses. The restraints imposed by the format represented a significant challenge to artists, and they often reveal Japanese art at its most elegantly stylized. Parasol in hand – like so many of the women in Impressionist art – the figure is squeezed into a thin band of space, her dark kimono set against the pale grid of a bamboo gateway behind her. The narrowness of the print accentuates the long line of the kimono, and the unnaturalistic sense of space. The pillar format inspired Degas (right).

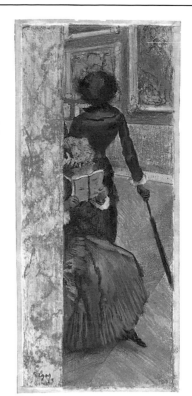

MARY CASSATT AT THE LOUVRE

Edgar Degas; 1885;
31.3 x 13.7 cm (12 x 5½ in); pastel over etching

The reference to Japanese pillar prints is clear in this superb picture of Mary Cassatt, who shared Degas' passion for Japanese art (pp. 56–57). Stylized and decorative, it echoes Japanese prints in a number of ways, besides its format: the high viewpoint; the overlapping of figures and their cropping off by the wall (that narrows the space even more); the uptilting of the floor; and the geometric background shapes, against which the figures are set. Even the way the line of Cassatt's suit is continued by the skirt of her companion evokes the long, sweeping curve of a kimono.

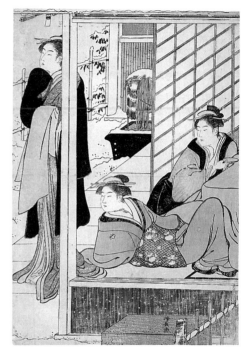

THREE WOMEN LOOK INTO A SNOW-COVERED GARDEN

Torii Kiyonaga; c.1786; woodblock print

Most *ukiyo-e* focused on the transient world of the theatre, and the daily life of prostitutes. Degas favoured similar subject matter; in both content and form, his café scenes (below and left) echo Kiyonaga's image of courtesans.

CAFE SCENE

Edgar Degas; c.1876; 27 x 29.8 cm
(10½ x 11¾ in); monotype

In Degas' monotype, as in his pastel (right), and Kiyonaga's print, an off-centre pillar stretches from the top to the bottom of the image, stressing the picture's flat surface.

WOMEN ON A CAFE TERRACE

Edgar Degas; 1877; 41 x 60 cm
(16¼ x 23½ in); pastel over monotype

Somewhat less stylish than their Japanese counterparts, four Parisian prostitutes watch potential clients go by. One rises from her seat, perhaps to follow the disappearing male figure, who is cut off by the door frame to the right. She herself is cut in two by a pillar.

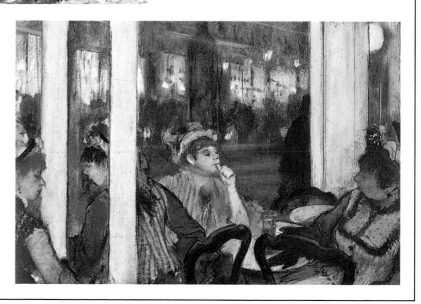

Index

Acknowledgements

PICTURE CREDITS

Every effort has been made to trace the copyright holders and we apologize in advance for any unintentional omissions. We would be pleased to insert the appropriate acknowledgement in any subsequent edition of this publication.

Key: t: top b: bottom c: centre l: left r: right

Abbreviations:
AIC: © Art Institute of Chicago, All Rights Reserved; AM: © Ashmolean Museum, Oxford; ATP: Musée des Arts et Traditions Populaires, Paris; BAL: Bridgeman Art Library, London; BHVP: Bibliothèque Historique de la Ville de Paris; BN: Bibliothèque Nationale, Paris; DR: Document Archives Durand-Ruel, Paris; JLC: Jean-Loup Charmet, Paris; MM: Musée Marmottan, Paris; MO: Musée d'Orsay, Paris; NG: Reproduced by courtesy of the Trustees, The National Gallery, London; NGW: © National Gallery of Art, Washington; PC: Private Collection; PM: David A. Loggie, The Pierpont Morgan Library, New York; PVP: Photothèque des Musées de la Ville de Paris; RMN: Réunion des Musées Nationaux, Paris; UFAC: Union Française des Arts du Costume, Paris; VL: Visual Arts Library, London; W&N: Winsor & Newton, Harrow

p1: c: MO p2: tl: Ministère de la Defense, Etat Major de l'Armée de Terre, Service Historique de l'Armée de Terre; tr: MO; cl: Charles H. and Mary F. S. Worcester Collection, AIC; cr: Wirt D. Walker Fund, photo: Robert Hashimoto, AIC; tr: thanks to Chat Degote, Paris; c: Collection Medici; bl: MO p3: tl: BN; c: The Stickney Fund © AIC; tr: Museum of Bradford; cr: © Société Française de Photographie; bl: Gaylord Donnelley Restricted Gift, Print and Drawing Club Fund, AIC; bc: UFAC; br: AM p4: tl: thanks to Melvyn Petersen, Artichoke Prints; tc: Potter Palmer Collection, AIC; c: AIC; cl: AIC; tr: UFAC; bc: PVP © DACS 1993; br: Musée de l'Orangerie, Paris p5: br: MO p6: cl: BN; br: BHVP; tc: PC; c: Musée Carnavalet/JLC; br: BHVP p7: tl: Mr. and Mrs. Lewis Larned Coburn Memorial Collection, AIC; tr: Musée de la Publicité, AIC, all rights reserved; b: NG p8: tl: Charles F. Glore Collection, AIC; cl: Charles Buckingham Collection, AIC; bl: PVP © DACS 1993 pp8–9: c: NG p9: tc, b: UFAC p10: tl: MO/© Photo: RMN; cr: Mr. and Mrs. Lewis Larned Coburn Memorial Collection, AIC; bc: Musée des Beaux Arts, Algiers/BAL; cr: MM; br: MO/VL p11: tl: MO/VL; bl: AM; c: Helen Regenstein Collection, AIC; bc: British Library, London; tr: Joseph Brooks Fair Collection, AIC; br: AM p12: tl: Lefranc & Bourgeois, Le Mans; bl: Charles H. and Mary F.

G. Worcester Collection, AIC; tr: MO/RMN; c: Giraudon; br: BN; cr: Louise B. and Frank H. Woods Purchase Fund (in honour of the Art Institute of Chicago's Diamond Jubilee), AIC; bl: The George A. Lucas Collection of the Maryland Institute, College of Art, on indefinite loan to The Baltimore Museum of Art, and Mr. and Mrs. Martin A. Ryerson Collection, AIC; cr: W&N; br: Mr. and Mrs. Lewis Larned Coburn Memorial Collection, AIC; bc: replica of Monet's floating studio built for the Société d'Economie Mixte d'Argenteuil-Bezuns by the Charpentiers de Marine du Guip, en l'Ile-aux-Moines (Morbiham) for Monet's 150th anniversary p14: tl: BN; br: MM pp14–15: Potter Palmer Collection, AIC p16: tl: BN; cl: Courtesy of The Fogg Art Museum, Harvard University Art Museums, bequest of Meta and Paul J. Sachs; bl: MO; br: PM p17: tl: Ministère de la Defense Etat Major de l'Armée de Terre, Service Historique de l'Armée de Terre; cl: AIC; b: Thanks to Henri Vuillemin; tr: Restricted Gift of Mr. and Mrs. Frank H. Woods in memory of Mrs. Edwards Harris Brewer, AIC; c: PVP © DACS 1993; cr: thanks to Patrice Reboul p18: c, bl: MO; tr: PM; br: JLC p19: tl: DR; cl: JLC; bl: MO; tr: MM; c: BN/Giraudon; br: Clarence Buckingham Collection, AIC p20: cl: BN; bc: RMN, H. Lewandowski; br: Louvre/Giraudon p21: tl: Osterley Park House, Middlesex/BAL; cl, r: MO; tr: ATP/© RMN; b: Sterling and Francine Clark Art Institute, Williamstown, Massachusetts p22: tl: By courtesy of the Board of Trustees of the Victoria and Albert Museum pp22–23: Mr. and Mrs. Lewis Larned Coburn Memorial Collection, AIC p24: cl: Clarence Buckingham Collection, AIC; bl: NG; br: Bequest of Clara Margaret Lynch in memory of John A. Lynch, AIC; br: ATP p25: tl: BN; cl: MO; tr: Mr. and Mrs. Lewis Larned Coburn Memorial Collection, AIC; c: Gift of the Prints and Drawing Committee, AIC; cr: Mme. Renée; br: thanks to Chat Degote, Paris; b: ATP p26: cl: JLC; bl: Mr. and Mrs. Lewis Coburn Memorial Collection, AIC; c: © Collection Viollet; br: © Harlingue-Viollet pp26–27: c: MO p27: br: Ordrupgaard Collection, Copenhagen p28: tl: AIC; bl: George F. Porter Collection, AIC; cr: Muybridge Collection, Kingston-upon-Thames Museum; br: Nelson-Atkins Museum of Art, Kansas City, Missouri (acquired through the Kenneth A. and Helen F. Spencer Foundation Acquisition Fund); cl: Museum of Bradford Science Museum; bl: By permission of Penguin Books, AIC; tr: © Société Française de Photographie; br: © Fitzwilliam Museum, University of Cambridge p30: JLC; cl: BHVP; bl: MO; br: MM pp30–31: c, br: Charles H. and Mary F. S. Worcester Fund, AIC p32: tl: Collection Medici; tr: BN; b: JLC/MM p33: cl: Petit Palais, Genève; cl: AM; Carnavalet/Photo: Bulloz, Paris; cr: Courtauld Institute Galleries, London; br: MO p34: t: artwork: James Mills-Hicks; cl: Musée de Vieil, Argenteuil; cr: MM; b: Potter Palmer Collection, AIC p35: MO/Giraudon; bl: Roger-Viollet; tr: Adaline Van Horne Bequest, Collection

of the Montreal Museum of Fine Arts/photo: Marilyn Aitkens, MMFA; c: NG; bc: Mr. and Mrs. Lewis Larned Coburn Memorial Collection, AIC; br: The Brooklyn Museum, gift of Dikram G. Kelekian p36: MO; cl: MO; bl: Collection of Mr. and Mrs. Paul Mellon © 1992 NGW pp36–37: Mr. and Mrs. Martin A. Ryerson Collection, AIC p38: tl: MO; cl: Monet's House and Garden at Giverny; tr: JLC; b: Mr. and Mrs. Martin A. Ryerson Collection, AIC p39: tl: Wadsworth Atheneum, Hartford, Connecticut, bequest of Anne Parrish Titzell; tr: © Harlingue-Viollet; c: Metropolitan Museum of Art, bequest of Joan Whitney Payson, 1975 (1976.201.14); b: MO; br: AM p40: © Collection Viollet; cl: Potter Palmer Collection, AIC; bc: AM; tr: MO/Giraudon pp40–41: AM p41: tr: AM p42: tl: BN; bl: Gift of the Helen and Joseph Regenstein Foundation, AIC; cr: Metropolitan Museum of Art, Wolfe Fund, 1907, Catharine Lorillard Wolfe Collection (07.122); br: DR p43: tl: AM; cl: AIC; bl: AIC; cr: AIC; cr: DR; br: AIC p44: Musée du Petit Palais/BAL; b: M. Theresa B. Hopkins Fund, courtesy of Museum of Fine Arts, Boston p45: tl: PC; Friends of American Art, AIC; tr: Photo: Routhier-DR; cr: AM; br: Gift of Kate L. Brewster, AIC; bl: Mr. and Mrs. Martin A. Ryerson Collection, AIC p46: tl: JLC pp46–47: The Stickney Fund, AIC p48: tl: BN; cl: MO; tr: thanks to Russell Harris p49: Potter Palmer Collection, AIC; tl: Gift of Robert Allerton, AIC; tc: Mr. and Mrs. Lewis Larned Coburn Memorial Collection, AIC; tr: MO/RMN p50: tl: UFAC; cl: thanks to Patrick Adam; cr: thanks to Gige; bl: Courtauld Institute Galleries, London; br: Musée de l'Orangerie, Paris p51: Gaylord Donnelley Restricted Gift, Print and Drawing Club Fund, AIC; b: Philadelphia Museum of Art, bequest of Charlotte Dorrance Wright; br: Chester Dale Collection, NGW; br: Gift of Mary and Leigh B. Block, AIC p52: tl: BN; tr: Mr. and Mrs. Martin A. Ryerson Collection, AIC; bl: Tate Gallery, London; bc: MO/RMN; br: Bequest of Adele R. Levy, AIC p53: tl: MO; tc: Gift of Robert Sonnenschein, AIC; b: Collection of Mr. and Mrs. Paul Mellon, Upperville, Virginia p54: cl: Museum of Fine Arts, Boston/Giraudon/BAL; bc: Monet's House and Garden at Giverny; tr: Gift of Gaylord Donnelley in memory of Frances Gaylord Smith, AIC; br: Pushkin Museum, Moscow/BAL p55: l: Clarence Buckingham Collection, AIC; tc: Gift of Kate L. Brewster Estate, AIC; c: Through prior bequest of the Mr. and Mrs. Martin A. Ryerson Collection, AIC p56: tl: BN; cl: Chester Dale Collection, NGW; bl: Wirt D. Walker Fund, photo by Robert Hashimoto, AIC; c: Potter Palmer Collection, AIC;

br: Bequest of Kate L. Brewster, AIC p59: tl: AM; tr: Mr. and Mrs. Martin A. Ryerson Collection, AIC; c: Helen Birch Bartlett Memorial Collection, AIC; bl: AIC; br: MO p60: tl, cl: Tate Gallery, London; b: © Detroit Institute of Arts, gift of Mrs. Christian H. Hecker pp60–61: c: artwork: Sallie Alane Reason p61: tl: courtesy of the Wilson Steer Estate/Fitzwilliam Museum, Cambridge; tr: Australian National Gallery, Canberra; tc, tr: Photo: Jacques Lathion, Nasjonalgalleriet, Oslo; cr: Stedelijk Museum, Amsterdam; br: Kume Museum, Tokyo p62: tr: DR p63: l, r (details): AIC Front cover: tl: ATP; crt: AIC; cr: Mme. Renée; crb: AIC; bc: AM; bl: Courtauld Institute Galleries, London; clb: thanks to Gige; clt: BN; c: MM Back cover: tl: BN; tr: AIC; crt: MO; br: thanks to Russell Harris; bc: ATP/© RMN; bl: AIC; clt: AIC; c: Two Sisters, Renoir, AIC (also cl, cr: details) Inside front flap: t, b: AIC

Additional Photography: Alison Harris: p2: tl, ct, cb; p9: br; p17: tl, b, cr; p24: bc; p25: cr, br; p30: cl, tc, bc; p32: tl; p33: tr; p50: cl Philippe Sebert: p1: p2: tr, bl, br; p5: br; bc p16: bl, br; p18: c, tl; p19: bl; p24: br; p25: cl, bl, br; pp26–27: c; p30: bl; p33: bl; p36: cl; p39: bl; p45: tl; p48: cl; p53: tl; p59: br; front cover: bl; back cover: cr Phillip Gatward: p20: Susanna Price: p4: br; p13: cr, bc; p14: tr, cr; p22: cl; p30: br; p32: tl; p34: cl, br; p38: tl, cl; p50: br Alex Saunderson: p19: tr

Dorling Kindersley would like to thank:
Robert Sharp, Gloria Groom, John Smith, Inge Fiedler, and Elisabeth Dunn at the Art Institute of Chicago for all of their assistance. Also, the DK studio; Alison Harris for additional research in Paris; J. Patrice Marandel at the Detroit Institute of Art; Joseph Baillio of Wildenstein & Co., New York; the Service de Documentation at the Musée d'Orsay, Paris; and the Ashmolean Museum, Oxford, for allowing access to the Pissarro Archives. Thanks also to Mark Johnson Davies for design assistance, and Jo Evans for picture credits.

Author's acknowledgements:
I'm very grateful to the staff at the Art Institute of Chicago who made my research there so enjoyable and productive – in particular Robert Sharp, Associate Director of Publications, and Gloria Groom, Curator of European Paintings. Many thanks to my friends Amy Ambrose and Koyo Konishi for their kindness during my stay in Chicago. I'm grateful, as always, to Ian Chilvers for the extended loans from his library. Thanks also to Andy Welton for advice on horseracing; to Jane Gifford and Ann-Marie Le Quesne for their comments on printmaking techniques; and to David Edgar for his support and encouragement. The Eyewitness Art team deserve a special mention, particularly Luisa Caruso and Liz Sephton, with whom I've worked most closely. Finally, I'd like to say thanks to my parents, Aud and John Welton. I dedicate this book to them, with love.